AROUND
HASLEMERE
& HINDHEAD
From Old Photographs

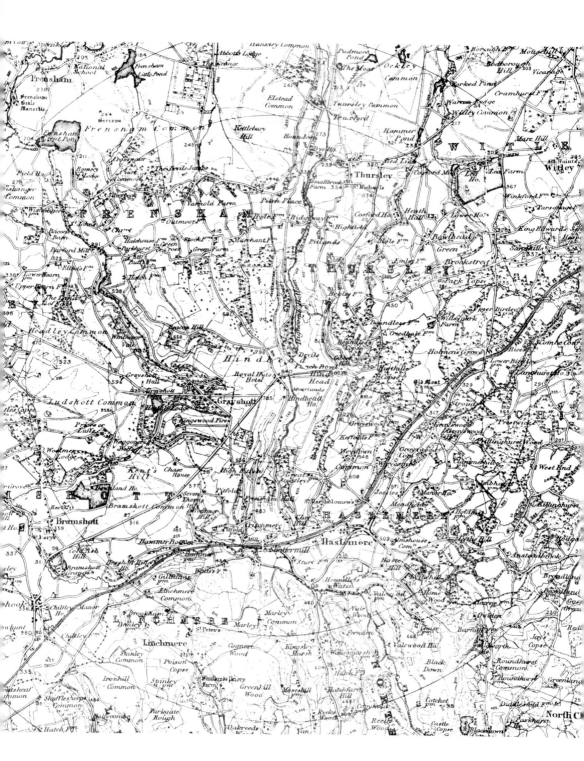

AROUND
HASLEMERE
& HINDHEAD
From Old Photographs

TIM WINTER &
GRAHAM COLLYER

AMBERLEY

First published by Alan Sutton Publishing Limited, 1991
This edition published 2009

Copyright © Tim Winter & Graham Collyer 2009

Amberley Publishing
Cirencester Road, Chalford,
Stroud, Gloucestershire, GL6 8PE

British Library Cataloguing in Publication Data.
A catalogue record for this book is available from the British Library.

ISBN 978-1-84868-312-9

Typesetting and origination by Amberley Publishing
Printed in Great Britain

CONTENTS

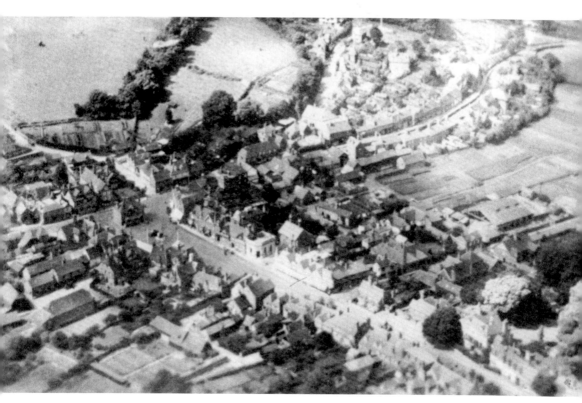

HASLEMERE photographed from an aeroplane in 1922. Seventy years ago the town was still intimately in contact with the surrounding farmlands which spread towards the High Street in fingers between the buildings that followed the roads. Between Lower Street and West Street a variety of crops is growing in discrete patches, where there was a market garden on land now filled by car parks and buildings including the telephone exchange and fire station. This area was once called Bunkhurst Meadow and as early as 1820 was threatened with a housing development – but that never took place.

INTRODUCTION

Haslemere is situated in the extreme south-west corner of Surrey at the point where three counties meet. The town, nestling between the hills of Hindhead, Blackdown and Marley, owes its position to the geology of the area. The hollow in which it has developed is the result of the headwaters of two river systems, the Wey and the Sussex Arun, each cutting back into the soft sandstones of the Lower Greensand until their valleys reached the impervious Atherfield clay.

These valley bottoms, however, tend to be rather damp and the first settlements in the area were on the more easily cleared and drier hilltops where the vegetation was less dense. Evidence of human life dating back some 10,000 years has been found on Blackdown where Stone Age man made tools out of flints brought to the area from a chalk district. Later, people moved into the valley bottoms where water was more readily available, both for domestic use and subsequently for industrial development.

The town of Haslemere grew very slowly from the time it was first mentioned in the early thirteenth century, when the market was granted to Richard, Bishop of Salisbury, until the middle of the nineteenth century. Then, in 1859, the railway arrived and the town, which had been passed by the London to Portsmouth coach road over Hindhead, was now connected to Guildford and London, and to the south coast. The population, which was 840 in 1842, grew to 2,650 by 1903 and 4,340 by 1931. Soon after this local boundaries were changed and by 1954 there were 11,740 people living in the area administered by the Haslemere Urban District Council, first formed in 1913, which included Hindhead and Beacon Hill, but not Hammer or Camelsdale which are in West Sussex.

It was in the latter half of the nineteenth century that several artists and writers were attracted to live in or around this quietly growing but still relatively unspoilt small country town. Walter Tyndale and J. W. Whymper lived in the town and Helen Allingham visited friends here and painted watercolours of several local cottages. Authors attracted to the area included George Eliot at Shottermill, Arthur Conan Doyle and George Bernard Shaw at Hindhead, and Lord Tennyson.

Hindhead and Beacon Hill grew as a result of a discovery made by an eminent scientist whose poor health necessitated his annual removal from a damp London winter to the drier, invigorating climate of Switzerland. Professor John Tyndall and his wife Louisa decamped every year to the Alps where, as a fitter, younger man, he had established himself as a mountaineer of some repute. But when, in the early 1880s, he was introduced to the spectacular heathery heights of Hindhead he fell at once in love with the place, then so little despoiled by development. Tyndall acquired land close to the Royal Huts Hotel, beside the crossroads formed by the great Portsmouth road and the no less important Farnham to Haslemere road, and for two years, while he was building Hindhead House, he and his wife lived in a hut in the grounds.

Tyndall found the Hindhead air, almost 900 ft above sea level, to be as clear and every bit as healthy as that from which he had benefited for so long at Bel Alp. As a scientist, he quite naturally did not wish to keep this discovery to himself, and either in his writings or by his frequent visits to the capital, he gradually spread the word about this wonderful hilltop settlement crossed by coach and four and indeed not too distant from the London & South Western Railway station at Haslemere. Hindhead, then, owes its development to John Tyndall, for when he took up residence in the mid-1880s there was very little building, but in his remaining years (he died in 1893) and for a decade after that houses and business premises sprung up like mushrooms.

There is no record of Tyndall ever having regretted making Hindhead so popular, but at least one other distinguished professional, who had followed the scientist's lead, moved on when he considered the area had lost its charm to the developer. And, of course, Shaw, who had spent his honeymoon at

Pitfold House, just off the Portsmouth Road, and then rented a substantial residence with an entrance from that very road, found the peace and quiet he coveted was not available and made a swift retreat.

These early days in Hindhead largely shaped the community round about. Beacon Hill, where the majority of the village population now lives, quickly became home to the working classes, many of whom found employment at the 'big houses' or in the hotels which were built in response to a demand for holiday accommodation.

Grayshott, which had begun to take shape at about the time of Tyndall's discovery, offered, as it strives to continue to do today, a range of shops and tradesmen to cater for both the residents and the visitors. As the motorcar became more commonplace so Hindhead and district prospered. Tea rooms abounded to cater for the day trippers, and as the hotels began to put up the 'no vacancies' signs so private houses offered bed and breakfast and others were converted into apartments.

The commons were the great attraction. By the early years of the twentieth century the Devil's Punch Bowl and Gibbet Hill were already owned by the National Trust – bought by public subscription when there was a danger of encroaching development – and they quickly became a playground for Londoners only too pleased to leave behind the smoke and the grime for a few hours.

Until these changes took place the mainstay of the local population had been the land. Some industrialisation had occurred during the later medieval, Tudor and Stuart periods, when the manufacture of iron and glass was centred on the Weald. Several iron furnaces and hammers were sited around Haslemere. Woodlands in the area provided many jobs and crafts such as charcoal burning, woodturning, broom and hoop making. With the arrival of the developers, brickmaking became important, and specialist workers came to the district from Kent. This led to a period of growth, with many new jobs in the building and allied trades. Substantial villas built around the area provided opportunities for girls to go into service.

So the sleepy little town and surrounding villages were transformed during half a century – and of the changes that occurred, many were recorded by photographers and artists, and some are collected together in the following pages, together with reminiscences of the way people worked, played and helped each other in this once forgotten corner of a rapidly changing world.

SECTION ONE

Haslemere

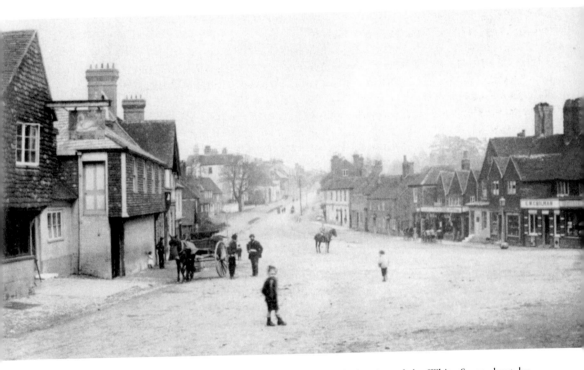

THE HIGH STREET looking north around 1890. On the left the sign of the White Swan, kept by Frank Gibbs, hangs outside the seventeenth-century inn building as it appeared before reconstruction just after this photograph was taken. Beyond is the new Workmen's Institute built by Stewart Hodgson and opened in 1886. Across the road Alfred Softly supplied meat and other provisions while, next door, Edward Chilman sold wines and spirits. Just beyond there is a fine display of perambulators outside the drapers shop of William Tanner.

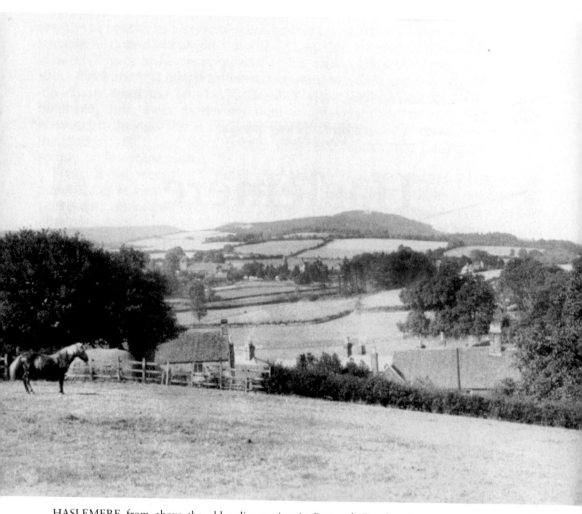

HASLEMERE from above the old police station in Petworth Road, a house now known as Old Coppers. This view towards Hindhead was photographed by John Wornham Penfold around 1880 and shows clearly how much agricultural land has disappeared as the town expanded not only westwards towards the railway and beyond, but also to the south. The field where the horse is standing was known as Jackmans on an 1867 tithe map. Across the rooftops the large field, once known in part as Pope's Mead, otherwise Town or Bell Mead, is now crossed by West Street. To the right were Town Field and Path Field, both crossed by the footpath from the High Street that is now part of the Greensands Way. Beyond St Bartholomew's Church and Peperham House the Old and New Kiln Fields, once part of Church Hill Farm, are skirted by High Lane leading up to Weydown Common and then down to Weydown Farm, where Sir Jonathan Hutchinson built Inval after he bought the farm in 1872.

EAST STREET LOOKING WEST on 23 August 1876. The old houses, known as Thursley End because they marked the meeting place of that parish with Chiddingfold, were built in 1639 by a carpenter called Francis Jackman. East Street was long known as Cow Street but only comparatively recently has it become Petworth Road. Museum Hill did not appear until nearly twenty years later when Sir Jonathan Hutchinson opened his museum in 1895.

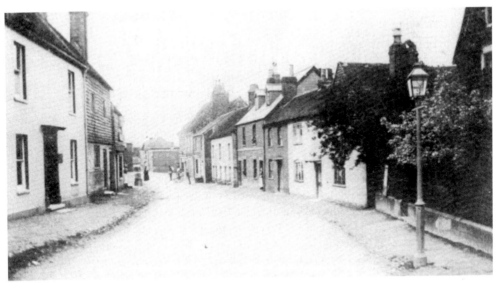

PETWORTH ROAD around 1895 looks very little different today almost a century later. The furthest white building on the right was once the Cow Inn and during the eighteenth century had been the reason why a forty-two stanza ballad had been composed in Oxford when the freehold of the inn was divided to provide eight votes in the 1754 parliamentary election. More recently the old Cow Inn was the Blackdown Bookshop. The white cottage on the left, known as St Helliers, was the home of Turner Bridger.

EDWARD GANE INGE came to Halsemere from Farnham in 1898 to open a pharmacy, probably at the shop that had been used until then by Peter Aylwin (see p.21). A leaflet advertising the shop announced 'a high class Dispensing and Photographic Chemists also agent for The Scottish Widows Assurance Society'. By 1901 the business had moved to premises vacated by the draper Stephen Tanner and is now Kingswood Chemists. During the next six years Edward Inge opened further shops in Bordon, Chiddingfold, Grayshott and Liphook. He published postcards which are a valuable record of the area during the Edwardian era. They were supplied wholesale to other shopkeepers besides being retailed in his own shops. Between 1907 and 1909 Edward Inge sold all five shops and then moved to Mundsley in Norfolk.

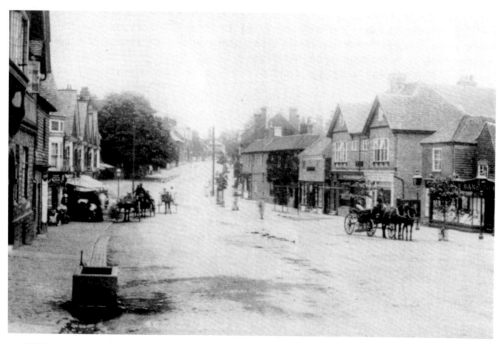

A BUSY SCENE in 1901 with quite a crowd outside the ironmongers shop of Robert Miles at the corner of the Broadway. Across the road Edward Inge has just opened his new pharmacy, having moved down recently from a shop near Well Lane. Next door are the Haslemere Dairy and the butchers shop of William Furlonger. The horse trough outside the Workmen's Institute was given by Stewart Hodgson to celebrate the Diamond Jubilee of Queen Victoria in 1897, another placed at the corner of St Christophers Green is still there today planted with flowers.

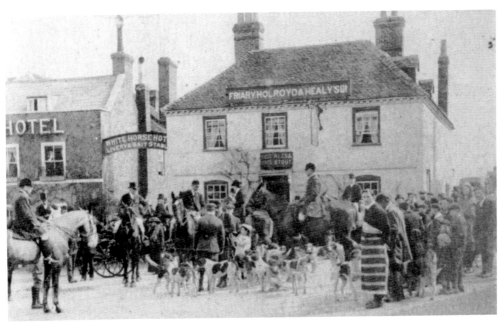

THE CHIDDINGFOLD HUNT outside the King's Arms in the High Street. The hunt had been founded in 1863 by Mr J. Sadler. The master, when this meet took place in 1909, was G. H. Pincknard of Combe Court, Chiddingfold. No doubt this was a good day for landlord George Moorey and also Edward Chase next door at the White Horse.

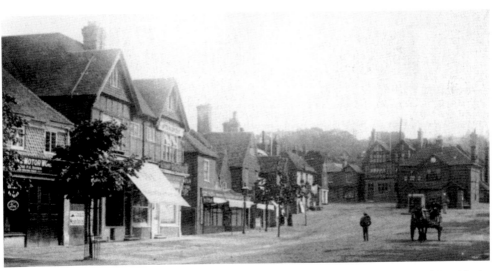

THE HIGH STREET around 1910 is still very empty but Green's Motor Works to the left heralds the changes that the arrival of the motor car will soon bring. Next door Edgar Cox sells fruit and vegetables while the Haslemere Dairy has tea rooms above. Beyond the gap that is now the supermarket car park entrance, the upper storey of the next building is flat; it has since had a bow-front added. At the chemists, Wiles and Holman are established as successors to Edward Inge. Outside the Town Hall the new electricity sub-station had been installed in 1909 and the town no longer depended on gas for lighting.

THIS VIEW OF THE HIGH STREET was photographed around 1890 just before major alterations were made to the west side. The first house on the right was Angel Cottage, formerly the Angel Inn. Next was a field gate opening to the footpath that followed a little stream across the meadows, where West Street is now, and out to Tanners Lane. The stream emerged from a causeway at the lowest point in the road, hence the name Causewayside for the buildings between West Street and the Georgian Hotel. Beyond the field gate the house half hidden by bushes was where Dr Clothier lived. During the 1890s this was demolished and replaced with The Broadway, an extraordinary turreted extravaganza for Haslemere High Street. Across the road the house on the left with four steps was home for Dr Whiting, medical officer for the area. This house and two pairs of shops and cottages to the south were demolished around 1930. In the distance the hills were still covered in fields where animals from Half Moon Farm grazed under the watchful eye of cowkeepers such as William Heath who lived in one of the cottages on Shepherds Hill.

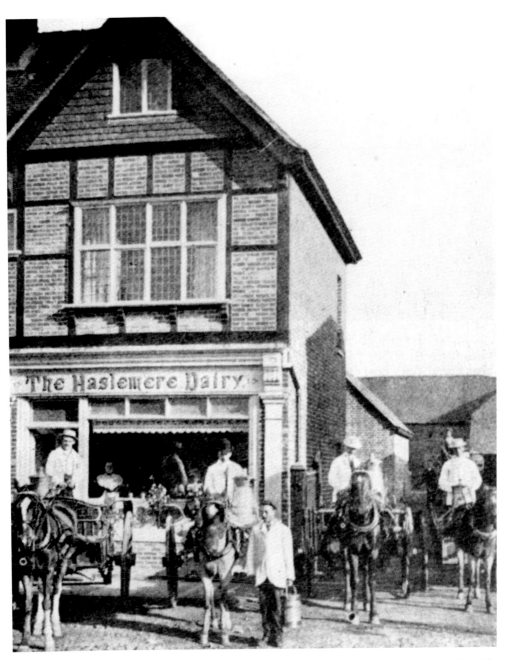

THE HASLEMERE DAIRY was on the east side of the High Street. The entrance on the right leading to the sheds behind is now the roadway into a private car park behind the furniture shop. An advertisement in 1903 claimed 'The milk is received twice daily direct from the farm situated one mile distant. Our stock open to inspection daily. Model cow sheds. Pure water supply'. In a room above the shop, afternoon teas were served to patrons and the same proprietor offered a similar service to his customers at the White Heather Dairy in Headley Road, Grayshott.

Photographed Sat July 6, 1912. Last day of business previous to demolition

THIS GROUP OF SHOPS stood on the east side of the High Street and was demolished in the summer of 1912 to make way for the London County & Westminster Bank (now the NatWest Bank Ltd). Three businesses were swept away: the hairdressers on the left had been Martin Tim's post office ninety years earlier; Ernest Appleby's boot and shoe shop moved to Electra House then newly built at the top of Wey Hill; and Sydney Rogers, corn merchant, crossed the High Street to the corner opposite College Hill.

THE HIGH STREET in 1937 and already the motor car is beginning to fill up the wide and formerly empty street. The war memorial, designed by local architect Inigo Triggs and erected in 1921, stands about where the butchers shambles were 200 years earlier. Until 1901 the bi-annual cattle market and fair had been held here in May and September. Since 1906 the fun-fair at Wey Hill has been the continuation of these traditional dates. It is also difficult to imagine that no regulations governing traffic flow in the High Street existed in 1937, even more dangerous perhaps than the 5 November fireworks celebrations when a bonfire used to be lit in the middle of the road.

THE HIGH STREET looking south soon after 1900. The changes from 1890 can be seen by referring back to page 14. Angel Cottage is still there, it was not knocked down until the late twenties. However, West Street had appeared but with a railing still across the causeway at the entrance. On the corner of the Broadway, Stokes grocery stores and hygienic bakery also offered tea, coffee and refreshments, a service that Charles Burgess continued, from around 1905, for many years in the room above the shop.

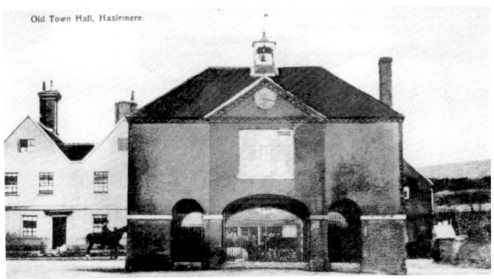

Old Town Hall, Haslemere.

THE TOWN HALL was built in 1814 to replace the earlier hall and market house that had stood further down the High Street. This view, from a photograph taken around 1862, was published as a postcard in 1905. The area under the arches appears to be in use as a lock-up. The room above was the infants school until 1900. The first public library in Haslemere was also in the Town Hall from 1865. The building to the left had been the house and grocery shop of James Hall in 1820 but was demolished soon after 1900.

ROAD REPAIRS near the spreading chestnut tree in the 1880s. Pot holes were filled with stone chips; in this part of the country local chert rock was most often used. As Haslemere developed, people moved here from London and many of these 'townies' complained about the state of the roads and pavements during wet weather. It was not until around 1910 that tarmacadam began to be used but most local roads were not surfaced until after the First World War – country lanes even later.

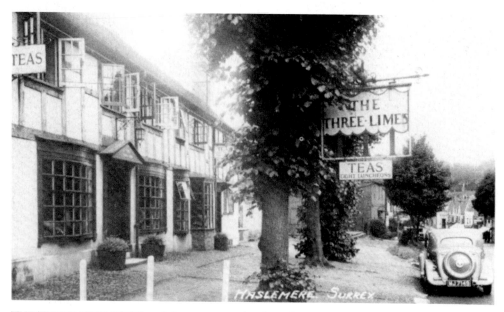

THE THREE LIME TREES and the tea rooms that bore their name were a familiar landmark in the High Street for many years.

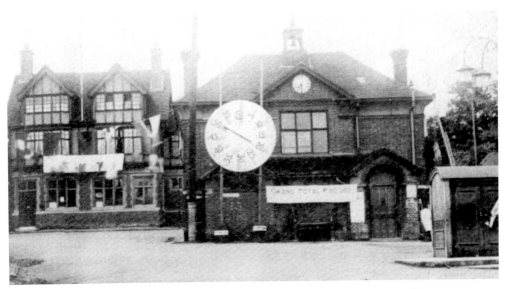

THIS ENORMOUS INDICATOR in front of the Town Hall shows what a considerable sum of money was raised by people in the Haslemere area during the First World War. Contributions for this 'Weapons Week' were accepted at the bank behind the Town Hall where Harold Raxworthy was the manager. The Capital and Counties Bank, now Lloyds, had come to the town in 1891 although the new bank was not built until just after 1900.

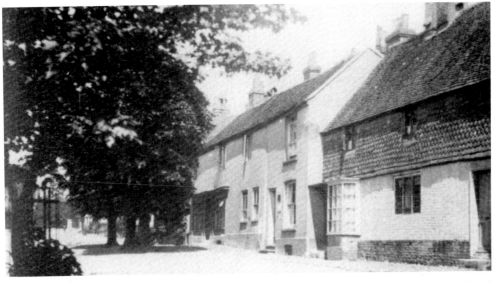

LOOKING UP THE HIGH STREET from Well Lane in 1913 the writer of this postcard complained about the width of the pavements. The little square window jutting out from below the fish-scale hanging tiles on the nearer cottages was a sweet shop where local children would have pressed their noses against the glass to see the mouth-watering confectionary on display within. Later in the 1930s it was here that fabrics made by Haslemere Weaving and Handicrafts were sold.

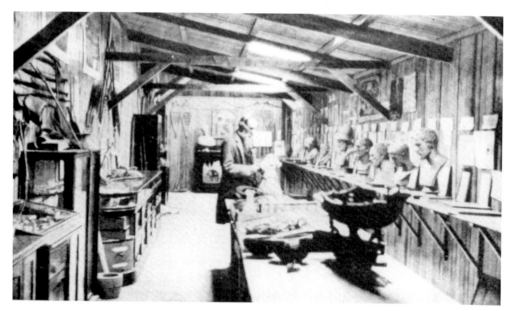

SIR JONATHAN HUTCHINSON in his museum in 1897. Sir Jonathan was born at Selby, Yorkshire in 1829. He qualified as a doctor and in 1862 became a Fellow of the Royal College of Surgeons. Soon after, he bought Weydown Farm in Bunch Lane and built Inval. The museum began there in a log hut in 1888. Seven years later the collections had outgrown this humble start and he built a museum where visitors were able to learn about history and the natural world.

THE FIRST HASLEMERE EDUCATIONAL MUSEUM was a single-storied wooden building (right) above the Petworth Road. Here Sir Jonathan and his curator E. W. Swanton lectured to local people on a wide variety of subjects. After Sir Jonathan died in 1913 the museum continued to grow. In 1926 a new home was found, paid for by public subscription, and the old building stood empty until 1929 when it became the offices of Haslemere Urban District Council. After the formation of Waverley Borough Council in 1974 the building was demolished – but the name Museum Hill reminds us where it once stood.

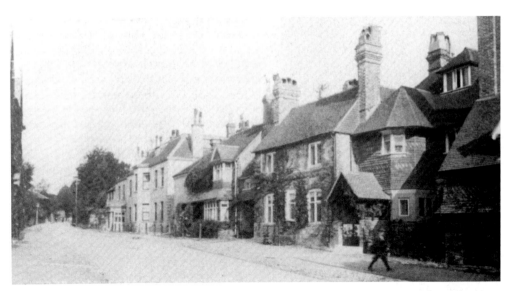

THE UPPER PART OF THE HIGH STREET around 1905. At this time Miss Hesse, daughter of the Revd Hesse who was the last rector of the old and larger parish of Chiddingfold until 1868, lived at The Lodge, the last building on the right. In 1926 this became the home of Haslemere Educational Museum when, on the death of his aunt, Major John Hesse moved across the High Street to live at Olivers. The building shown centre right, now an estate agent, was known as Goodwyns and it was here that Will Moorey, surveyor responsible for two eighteenth-century borough maps lived.

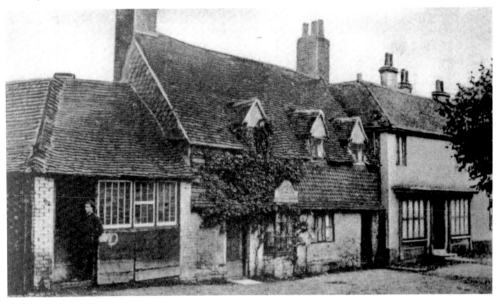

THE OLD SMITHY run by Jane Bridger around 1890 was close to the present-day museum. Next door Arthur Williamson sold fish from an attractive tile-hung building, once painted by Helen Allingham, and which is now offices. The right-hand shop belonged to Peter Aylwin who dabbled in many trades. He was the chemist until 1898, dealt in antiques, was both secretary and manager of the Haslemere Gas Company and owned clay pits at Wey Hill – evidently not a man to put all his eggs in one basket.

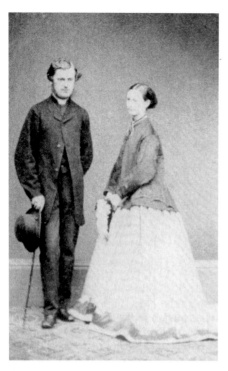

SANDERS AND ADA ETHERIDGE, photographed at Ambleside in May 1868, were soon to play an important role in the story of Haslemere. Later that year he was appointed as first rector at St Bartholomew's church when the new parish of Haslemere was separated from Chiddingfold. He succeeded the Revd Hesse, rector before the parish was split, who had lived at the house which is now the Haslemere Educational Museum until he died in September 1868. Ada Etheridge was the daughter of the Revd Gibson from Blackwater near Farnham and her late grandfather had been Bishop Sumner of Winchester. Together the couple did much good in the town during the next twenty-five years but sadly Ada died in January 1893, soon after celebrating their Silver Wedding Anniversary in April 1892. After the death of his first wife Sanders Etheridge married Gertrude Fitzmaurice in April 1896 at the Garrison Church, Portsmouth. They left Haslemere the following year but on his retirement returned to live at Courtsmount until his death in 1912 when he was buried alongside Ada in the parish churchyard.

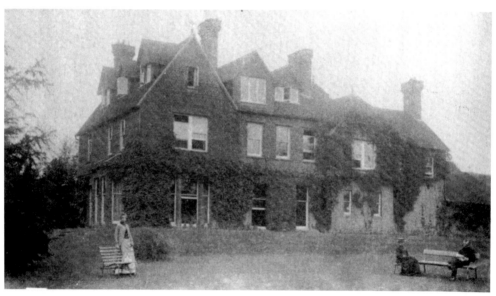

THE FIRST PROJECT of the Revd Etheridge was the building of a rectory. This was built around 1869 in the corner between Meadfield Lane, now Three Gates Lane, and the turnpike road to Grayswood and Milford. The land was then known as Rack Field and belonged to James Sadler. When Sanders Etheridge left the district in 1897 the Revd Aitken moved into the rectory but his successor Walter Wragge preferred the new and much smaller Glebe Cottage in Derby Road. The rectory became a private house called Sadlers.

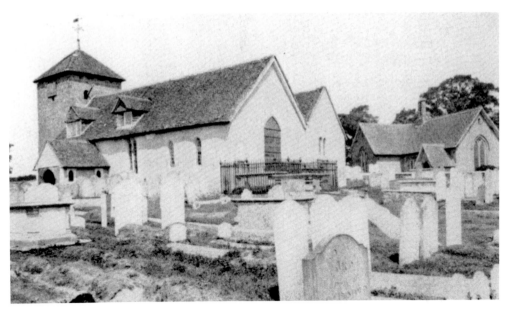

ST BARTHOLOMEW'S CHURCH was built as a chapel of the church at Chiddingfold and was known in 1180 as the chapel of Piperham. The estate of the same name was a large area of farmland surrounding the church. This picture shows the appearance of the church in 1870 before almost complete demolition which began on 25 July and rebuilding was completed by July 1871. In the background the National School was built around 1816. This photograph and the one below were taken by local architect and surveyor, John Wornham Penfold, who was much involved in the design of the new church.

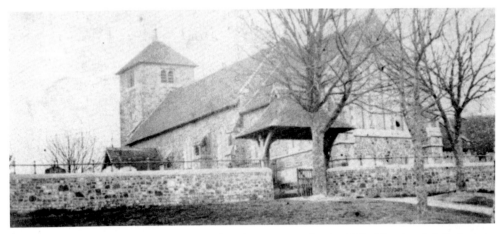

ST BARTHOLOMEW'S CHURCH soon after the reconstruction in 1871. The church bells had not been included in the rebuilding but by 1881 they were found to be both unsafe and damaged. A peal of six new bells was bought by public subscription and local benefactors who gave generously included Stewart Hodgson who was Lord of the Manor, The Earl of Derby, and West Surrey MP Mr George Cubitt. The bells were manufactured at a foundry in Whitechapel and rang out for the first time at 7 a.m. on Whit Sunday 1882. Later in 1888 it was necessary to add a new south aisle to the church providing another 120 seats for larger congregations as the town continued to expand.

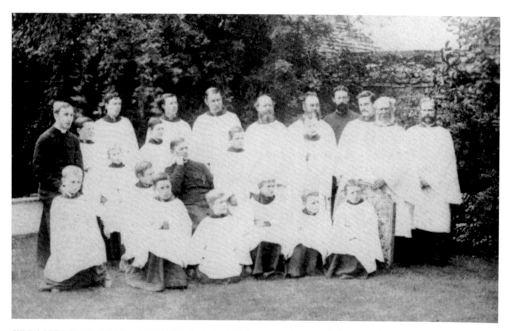

ST BARTHOLOMEW'S CHURCH choir in 1884 grouped around the seated Revd Sanders Etheridge in the churchyard.

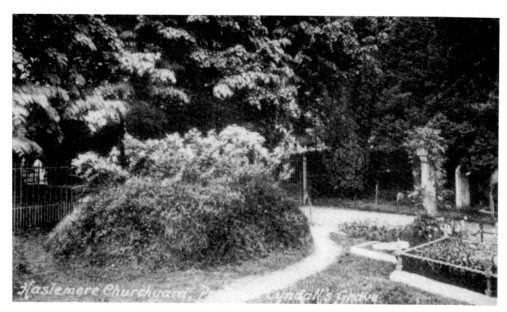

PROF. JOHN TYNDALL (see p. 51) who lived in Hindhead, and brought prosperity to the village, was buried in Haslemere after his accidental death by poisoning in 1893. He was laid to rest beneath a great mound of Hindhead heather in the cemetery across Derby Road from the churchyard. His widow was also buried there in 1940, and although there is still a mound it is of moss and grass with no sign of heather. An uncared for stone reads: 'In loving memory John Tyndall FRS scientist teacher mountaineer born 1820 died 1893 and Louisa Charlotte his wife born 1845 died 1940'.

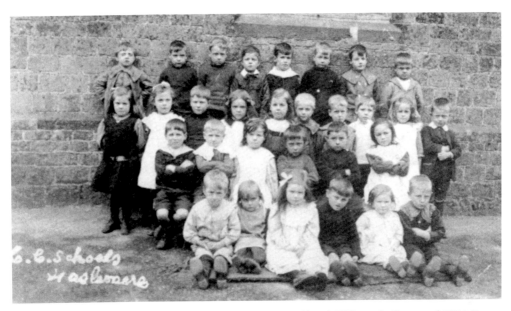

THE NATIONAL OR COUNTY COUNCIL SCHOOL on Church Hill was built around 1816. It was expanded several times, in 1873 under the guidance of the Revd Etheridge to take 145 pupils and in 1893 the capacity was increased to 225. Average attendances in 1899 were 102 boys and 90 girls but when the infants could no longer be taught in the Town Hall this influx of new pupils at Church Hill necessitated the building of a school for boys off West Street. The above group dates from around 1905 when the children came under the watchful eye of headmistress Miss Emma Palmer.

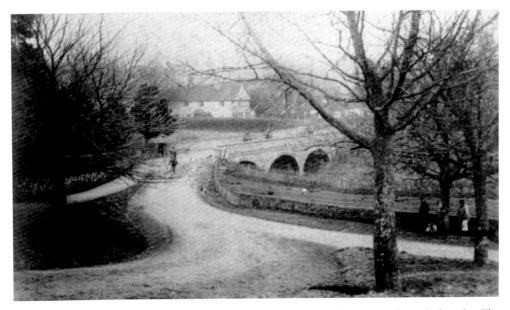

LOOKING EAST FROM CHURCH HILL around 1880, a view that has changed very little today. The Chiddingfold Hunt, seen crossing the railway bridge built in 1858, are on their way towards Weydown and the fields now covered by the High Lane estate.

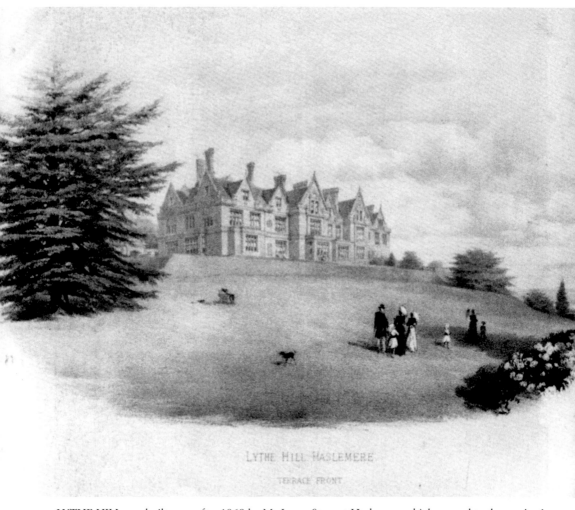

LYTHE HILL HASLEMERE

TERRACE FRONT

LYTHE HILL was built soon after 1868 by Mr James Stewart Hodgson on high ground to the south of the Petworth Road and below the track to Blackdown that is now Tennysons Lane. He had purchased Denbigh House in 1864, originally built by the notorious Revd James Fielding (see p. 110). He pulled this down and replaced it with a Tudor-style mansion, in red brick with terracotta dressings and panels together with mullioned windows, which was designed by his friend Fred Cockerell ARA. The house was very large and included on the ground floor a dining room, two drawing rooms, library, billiards room, smoking room and the usual domestic offices. The house contained some good contemporary art including four large fresco panels by Mr W. B. Richmond ARA in the small drawing room while in the larger one, which was thirty-six feet square, there were bronzes by Mr A. Gilbert ARA designed by Mr George Aitchison ARA and an overmantel by Mr S. Pepys Cockerell ARA. Upstairs the main bedrooms and nurseries were on the first floor with a further eight on the second floor from where the view extended as far as Hastings and St Leonards. After Stewart Hodgson lost much of his money when the business in which he was a partner collapsed, he moved to the Manor House in Three Gates Lane. Lythe Hill was purchased by Mr Richard Garton who lived there from 1902 until his death in 1934. During the Second World War the house was requisitioned by the Admiralty. After they left Lythe Hill it was totally destroyed by fire in December 1976 while being converted into luxury apartments.

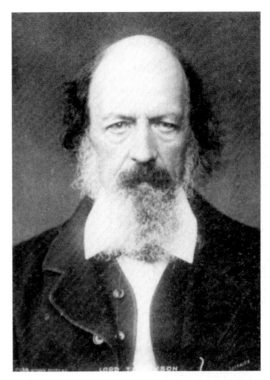

ALFRED LORD TENNYSON was born in Somersby Rectory, Lincolnshire around midnight on 5/6 August 1809, the son of the Revd George Tennyson and his wife Elizabeth. He first came to this area when he visited Stoatley Farm, Bunch Lane in 1864. He returned to Grayshott in 1866 and two years later bought land on Blackdown to build a summer retreat away from sightseers at Farringford, his estate on the Isle of Wight. He was made a baron in 1884 in recognition of his service to Queen Victoria as Poet Laureate. This photograph by Barraud was taken about four years later. When Tennyson walked around Blackdown with his dogs he dressed in a dark cloak and black sombrero hat. It is reputed that he wore a whistle round his neck to frighten away the sightseers – today we call them fans.

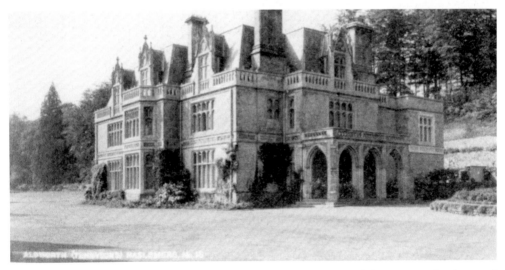

THE FOUNDATION STONE of Aldworth was laid on 23 April 1868 and the Tennyson family moved in the following year. What had originally been intended as a modest summer retreat turned into a ten-bedroomed mansion designed by a young architect called Knowles. Many famous people visited Aldworth including the Duchess of Teck who later became Queen Mary, the Gladstones and Helen Allingham. Lord Tennyson died on 6 October 1892 and was buried at Westminster Abbey. A memorial window to Tennyson was unveiled in 1899 at St Bartholomew's church. The window designed by Sir Edward Burne Jones depicts Sir Galahad and the Holy Grail.

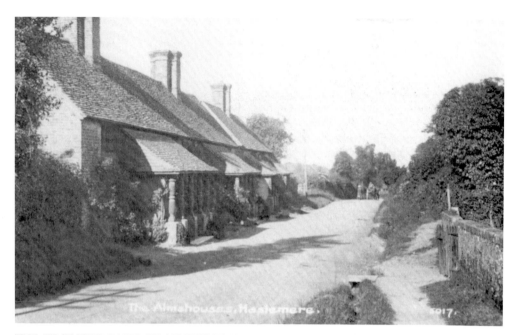

THE FIRST TWO PAIRS OF ALMSHOUSES were in 1676. Originally known as the Tolle House, they were built alongside the road to Chiddingfold with funds raised from the market and fair revenues collected after a Royal Charter was granted in 1596. By the end of the nineteenth century they had fallen into a poor state. The necessary repairs were paid for by Stewart Hodgson together with the addition in 1886 of an extra pair of cottages at the far end from Haslemere.

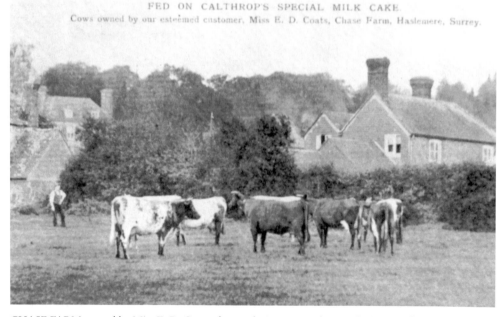

CHASE FARM owned by Miss E. D. Coats, featured on a postcard around 1905 to advertise Calthrop's Special Milk Cake Feed which she used for her herd of dairy cows.

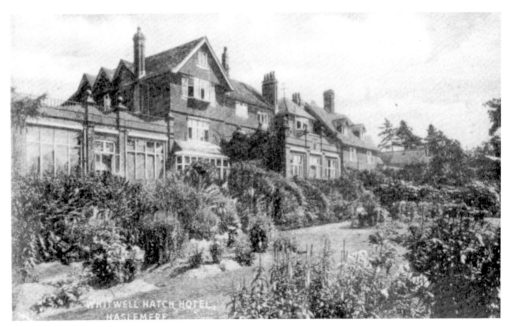

THE 6TH MARQUIS OF SLIGO changed the name of his house in 1911 from Highfield to Whitwell Hatch. His father had bought the house from Stewart Hodgson in 1894. Whitwell Hatch had been developed on the site of the Admiralty semaphore house after this ceased to be used in 1847. In the 1920s it became a hotel but was requisitioned by the Admiralty, together with Lythe Hill, during the Second World War. It became an hotel again after the war but is now apartments.

HASLEMERE WOMEN'S CLUB. College Hill offered a variety of social activities for members. The subscription in 1933 was 1s. a month, 10s. a year. For this girls over fourteen and women from a radius of twenty miles were able to read the newspapers, listen to the radio, and attend whist drives and dances. The club was open on weekdays from 10 a.m. to 10 p.m. and on Sunday from 2.30 p.m. to 10 p.m. Used as the Social Centre into the 1990s, the building is now a pre-school nursery.

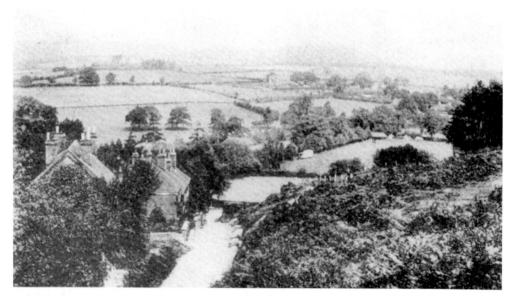

LOOKING ACROSS TANNERS LANE from Sandrock in 1900. The only houses to been seen before Church Hill are the cottages above Mr Penfold's house in Sandrock and beyond are the roof-tops of Oaklands where Mr Charles Boardman was living in Tanners Lane. Between there, the church, Bunch Lane and the High Street the open fields were only broken by the railway cutting.

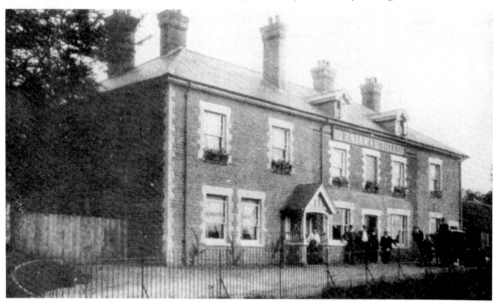

THE RAILWAY HOTEL was opened opposite the station soon after the first trains carrying passengers looking for accommodation began to arrive in Haslemere. During the 1890s the proprietor was George Edward Berry. He was followed by Thomas Castleman who, together with his wife Helen, ran the Railway for many years. In 1909 he advertised a railway, commercial and family hotel with spacious coffee and refreshment rooms. For a time the Railway was called the Haslemere Hotel but is now the Inn on the Hill.

THIS VIEW and the picture below are an interesting pair of postcards taken from Shepherds Hill and clearly showing the westward development of the town almost ninety years ago. This card was posted in 1905 and, apart from the new school and the headmaster's house, no other building in West Street had yet been built and Bridge Street did not exist.

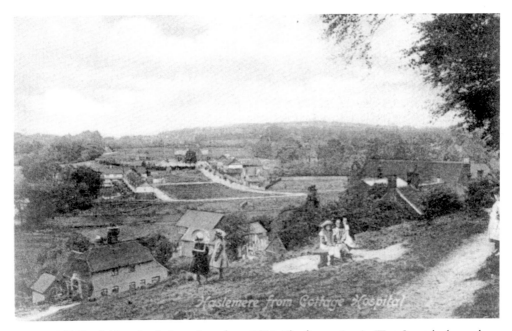

THE SECOND of this pair of views dates from 1906. The fire station in West Street had now been built, as well as the houses on the north side of Bridge Street and those in Popes Mead, part of the area known as the Haslemere garden suburb. A row of newly planted chestnut trees can be seen leading past the fire station to the school. Although these grew too large and had to be removed the cul-de-sac is still called Chestnut Avenue. Just visible on the left are the glasshouses of Oaklands Nursery in Tanners Lane (see p. 38).

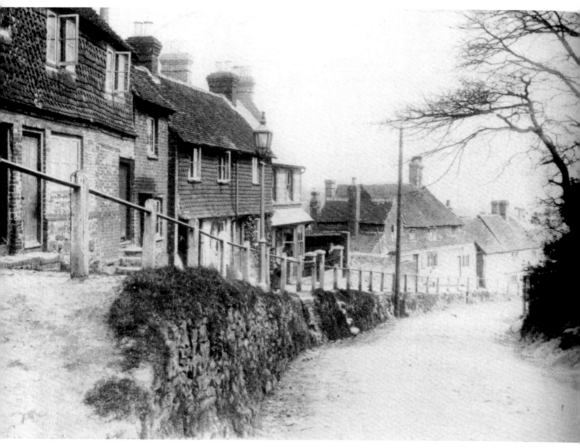

LOOKING DOWN SHEPHERDS HILL in 1899. The cottages in the left foreground are very similar today but all those buildings beyond the tall post were demolished in the 1930s, but not before the nearer pair were painted by Helen Allingham. The lower group of buildings were the Old Malt House where H. & J. Purkis supplied corn, grain, hay, straw and many other items needed for keeping a horse. It was just before the First World War that W. & E. Oldershaw opened the Empire Picture and Variety Palace, the first cinema in the town. This was built in the gap part way down the hill. However competition soon appeared on Wey Hill in the shape of the Regal Cinema (see p. 138) owned by the Haslemere Cinema Company who later in the 1920s bought out their competitors. The Oldershaws continued for some time at the Empire Tobacco Stores in Lower Street, a shop that now sells antique clocks. After the Empire closed the roof was altered and the whole cinema converted into the rather ugly flats whose gaunt wall faces you when entering Lower Street or Shepherds Hill.

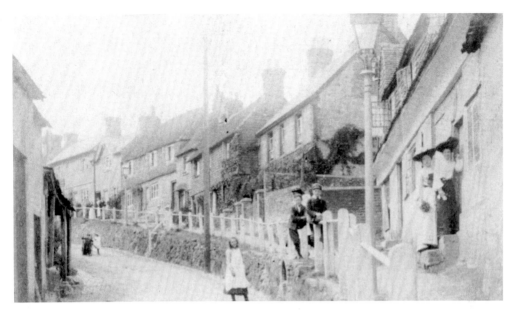

SHEPHERDS HILL became part of the turnpike road for coaches in the late 1760s. Before this coaches bound for Chichester from London or Guildford came down from Hindhead to the Sussex Bell, thus missing the town completely. Even after the necessary Act was passed only two coaches, both called the Duke of Richmond, called at the White Horse each day. Twentieth-century traffic requires more room than did eighteenth-century coaches and by the 1930s the houses and sheds on the east side of the hill were demolished, as well as the cottage where the two girls are standing in the doorway.

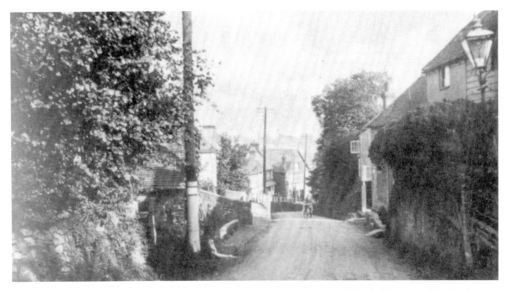

LOOKING DOWN SHEPHERDS HILL around 1930 the most noticeable difference is that the houses on the right are no longer there. Before these were knocked down the road was very narrow and even more dangerous than today. The Empire Cinema is conspicuous at the bottom of the hill.

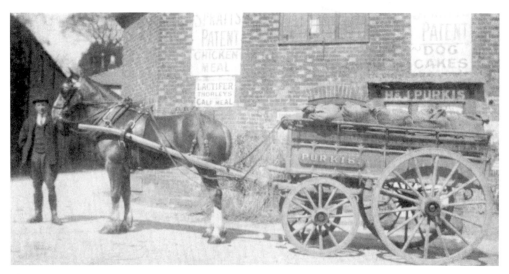

HENRY PURKIS with his horse and cart is standing outside the Old Malt House which was on the corner between Lower Street and Shepherds Hill. His father, Joseph, had originally come to the town in 1867 to work as steward to Stewart Hodgson (see p. 26). He started his business early in the 1890s so the claim in the advertisement (below) suggests a rapid change around of corn merchants in the town. Purkis horses are always large and powerful animals. This was essential as their other use was pulling the Haslemere fire engine to emergencies, a role they fulfilled until made redundant in 1934 by the arrival of a motorised machine. Soon after this the Old Malt House was knocked down to widen the end of Lower Street and later an air raid shelter was built where the shop had stood. But there are still some people who remember the rats and mice scurrying around the windows at H. & J. Purkis.

H. & J. PURKIS,

Maltsters, Hay, Straw ✑ ✑ and Corn Merchants.

The oldest established Corn and Forage Merchants in Haslemere.

Note the Address :—
The Old Malt House, Lower Street, HASLEMERE.

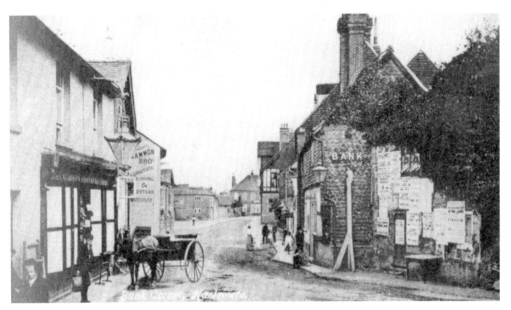

THE OLD IVY-COVERED BUILDING on the right, hidden by auction notices in 1904, had until recently been a pastry shop, but was now seriously dilapidated and soon to be pulled down – the site has only recently been redeveloped. Next door the bank was soon to become the second pharmacy in the town, opened in 1909 by Richard Harrison who also had a shop in Headley Road, Grayshott. Opposite the chemists, the building jutting out into the road was another demolished to make Lower Street wider.

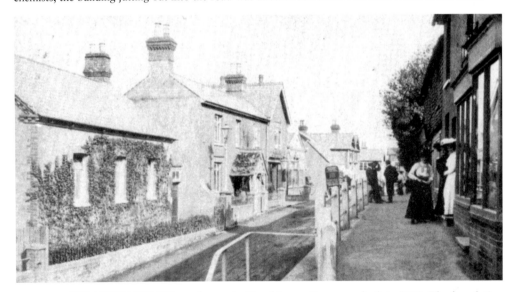

THE STRICT BAPTIST CHAPEL on the north side of Lower Street was built in 1862. The foundation stone had been laid on 12 May by William Wield and the building completed by November. Before this, meetings had been held since 1846 in a disused skittle alley in Well Lane. Rueben Harding, the pastor from 1856 till his death in 1888, used to baptize people in the stream at Bell Vale before the baptistry was added in 1866. The house beyond has been a shop or café for most of last century, but is now empty and awaiting redevelopment.

LOWER STREET on 28 April 1908 with the sign of the Good Intent outside No. 33. This public house was opened by a Godalming brewer in 1867 and closed about fifty years ago. At the yard on the corner Algernon Moon and Sons carved many of the tombstones now in the local churchyards. It was also about here that a pottery in the eighteenth century produced slipware decorated dishes for the local housewives.

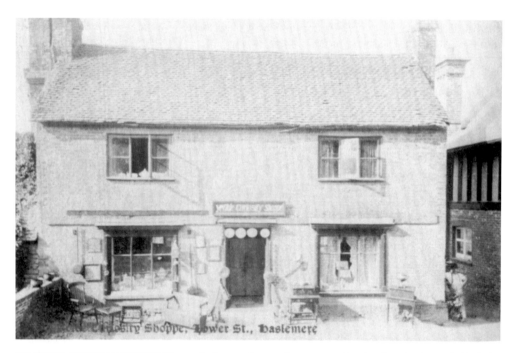

YE OLDE CURIOSITY SHOPPE was in Lower Street almost opposite the church. Around 1910 the proprietor Mr Brunel Hoyes offered a furniture restoration and re-upholstery service as well as buying and selling antiques. Earlier in the nineteenth century the building was the Anchor alehouse. After this closed the Good Intent opened just across the road so ale was still available in Lower Street.

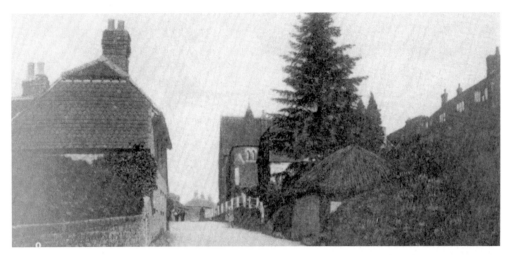

THE PILE WELL (or Pyle Well) in Lower Street was a spring in the bank above Pile Well Meadow, now called Town Meadow, at the corner of Tanners Lane. Before the parish council waterworks were opened in November 1907 Pile Well and the Town Well in Well Lane were the main public, but rather polluted, sources from which water carriers like old Hannah Oakford delivered buckets to the door, carried on a yoke, for three-halfpence each. Behind the thatched well stands the Congregational church (now the United Reformed church) built in 1881 adjoining an earlier church dating from 1804.

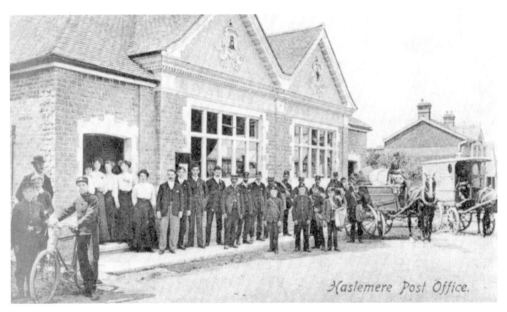

Haslemere Post Office.

THE NEW POST OFFICE was opened in 1906 in West Street after having been at several different addresses in the High Street and Petworth Road during the past century. The postmaster Mr Charman (immediately to the right of the ladies) also ran a newsagents and gift shop in the High Street with his partner Mr Hatch (now Nobbs). Before the First World War there were three deliveries and up to seven collections on weekdays. The telegraph boys on their bicycles delivered urgent messages when few people had access to a telephone.

A RATHER RURAL SCENE close to the town in 1910 at the point where Tanners Lane crosses the railway bridge. The road was probably so named because of the leather industry which was based in this part of the town from at least the fifteenth to the eighteenth century. During the earlier part of this century the large glasshouses of Oaklands Nurseries, run by Mr E. Welman when this photograph was taken, spread over much of the land between Tanners Lane and West Street. Here flowers, tomatoes, salad crops and more were sold in the little shop that stood about where the car park entrance is now, next to the houses at the junction with Bridge Street.

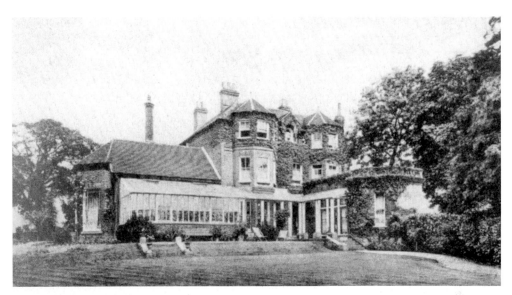

THIS FINE GEORGIAN HOUSE called Oaklands was probably built by William Bristow with money made by tanning leather in what is now Tanners Lane. Because of the smells associated this trade the tanneries were positioned well outside the boundary of the town. Later in the eighteenth century another tanner John Mitchell is known to have owned Oaklands. During the present century the house has been a hotel until the recent development of retirement homes in the grounds named after the large redwood tree planted there more one hundred years ago.

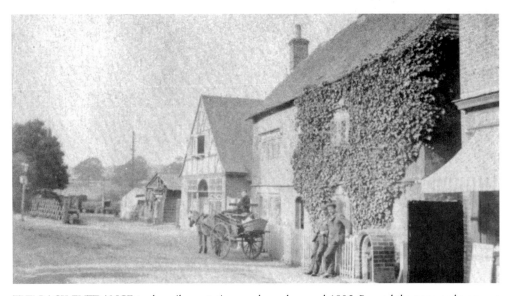

THE BACK ENTRANCE to the railway station goods yard around 1905. Beyond the pony and trap was the registered office of Chapman, Lowry and Puttick, the sheds behind and to the left were their timber stores. The creeper-covered Tudor House was once known as Sheepskin House, an obvious connection with cloth-making or the tanneries that were located this side of the town. In more recent years it has been a tea room, antique shop, estate agents, newspaper offices and is currently empty and undergoing restoration.

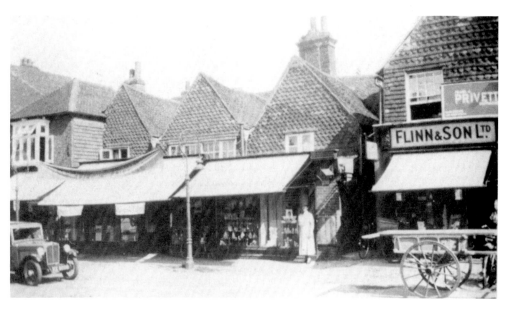

THE WELL-KNOWN TRIPLE GABLES of one of the oldest surviving buildings in the High Street. Since around 1900 the shop has been a pharmacy, Edward Inge until 1909, Wiles and Holman to 1922 then Blakers, Reids and now Kingswood Chemists. However back in the seventeenth century this building was almost certainly an inn called the Red Lion. An earlier connection is suggested by the badge of Henry VII, once present on an old window at the back of the building, but no other evidence exists to confirm a royal link.

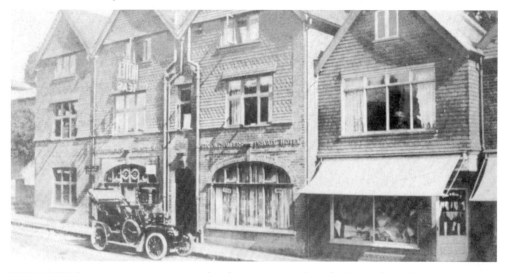

THE HAZELS was a private temperance hotel, restaurant and confectioners shop almost opposite the railway station in part of Station Chambers. The proprietresses, the Misses Blandon and Mouseman, paid an annual rent of £80 plus rates and taxes which was increased to £120 on Ladyday in 1911. When Station Chambers was sold by auction in May 1910 the offices at the far end were leased to solicitor Herbert Owtram for £57 per annum. The shop to the right, Madame Marie, was a milliner and has various items of clothing other than hats displayed in the doorway.

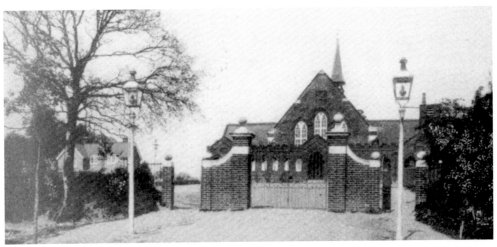

THESE IMPRESSIVE GATES made by William Maides, the Lower Street blacksmith, guarded the entrance to Haslemere School which was built by public subscription after the Bishop addressed a meeting at the White Horse Assembly Rooms in February 1898. The land on which the school was built was given by Miss Hesse. The contract to build the school was won by Messrs Tompsett and Co. of Farnham at a cost of £3,723 including the technical rooms and a further £650 for the headmaster's house. A new road, West Street, had to be constructed across Mr Ransom's meadow at an extra cost of £170. The school was designed for some 220 pupils under the supervision of Mr G. H. Tyler. It was opened on Tuesday 22 April 1900.

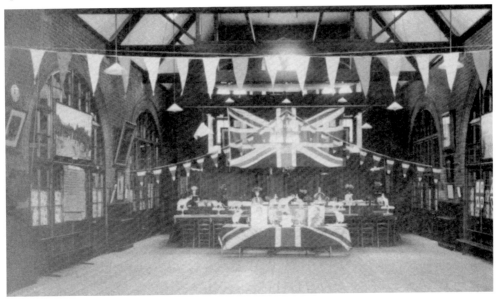

THE LARGE CENTRAL HALL of Haslemere School decorated for the Coronation of King George VI and Queen Elizabeth in May 1937. Before the Haslemere Hall was built this part of the school had been a great benefit to the community for meetings and theatricals. The first play staged here was *The Merchant of Venice* in February 1900, even before the school had been opened, but the purpose was to raise money towards the building costs.

KINGS ROAD was known originally as Foundry Road or Gasworks Lane. The name was changed in 1903 when King Edward VII travelled along it from Haslemere station to Midhurst to lay the foundation stone of the new hospital. More than eighty years later the view has changed very little apart from the disappearance of the railway house on the right which was demolished around 1960.

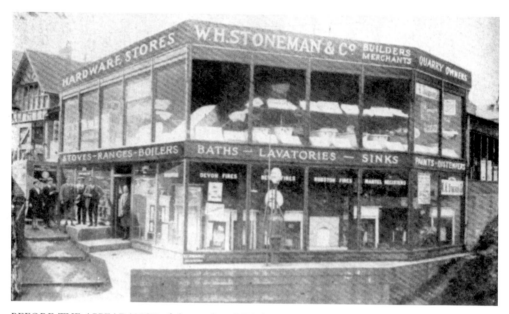

BEFORE THE APPEARANCE of the modern DIY shop most Haslemere handymen went to builders merchant W. H. Stoneman where all kinds of fittings were available. The entrance was in Kings Road but these fine displays overlooked the road at Fosters Bridge. The business started around 1908 but this view dates from the 1920s. Note the petrol pump on the wall and imagine stopping there now for a gallon of fuel.

SECTION TWO

Transport

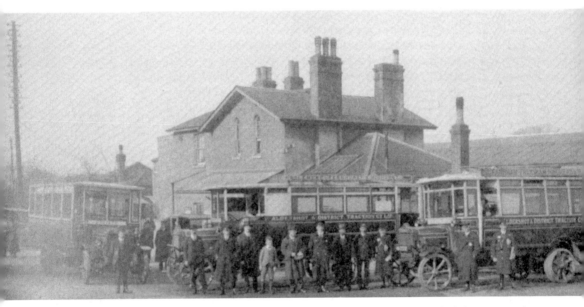

HASLEMERE STATION was built around 1858 and the railway line which had been privately constructed opened on 1 January 1859, an event that has had never-ending consequences for the growth and development of the whole district. The Aldershot and District Traction Company began running regular services from the station forecourt and by 1920 were using Daimler buses from the garage at Wey Hill. These services included the route to Farnham that had been operated until 1913 by the London & South Western Railway Company; also Ben Chandler's route to Grayshott (see p.53) was acquired in the same year.

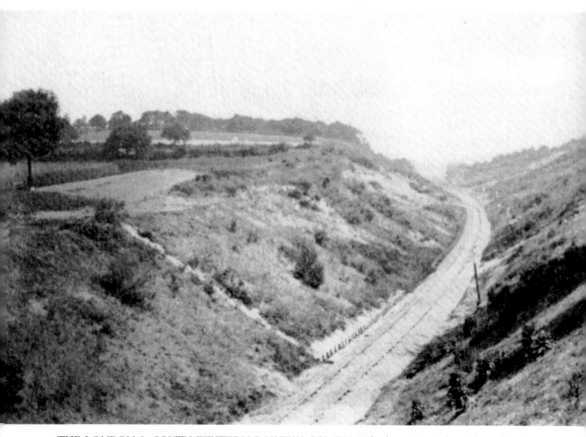

THE LONDON & SOUTH WESTERN RAILWAY COMPANY had constructed a railway line from London to Woking by 1841 and this was later extended to Farncombe. Meanwhile the London, Brighton & South Coast Railway Company track was built from Brighton westwards through Havant to Portsmouth. An independent group of contractors led by Thomas Brassey built a single track line to join these two systems together at Havant. It was during this work in 1855 that a group of navvies rather the worse for drink were confronted by Inspector William Donaldson and Constable James Freestone of the Surrey Constabulary who were joined by Dr Henry Bishopp who lived across the High Street from the White Horse. Trouble began in the tap-room of the King's Arms and continued outside into the early hours when Inspector Donaldson was brutally struck down with an iron bar and killed. Five men were later arrested and at the subsequent trial four were found guilty of manslaughter of whom the ringleader Thomas Woods was sentenced to transportation for twenty years. The railway line opened on 1 January 1859 and the above photograph shows the view looking north from the bridge at Church Hill around 1870. The size of the cutting, now obscured by trees, is clearly visible. The fields to the left were part of Church Hill Farm when the line was constructed, the first was called Saw Pit Meadow with West Field and Bull Field beyond, all owned at that time by the Revd Richard Parson. The railway line was widened to two tracks during the 1870s and completed for through trains to Havant and Portsmouth on 1 March 1879.

"Royal Huts," Haslemere, Hindhead & Grayshott Service.

TIME TABLE.

DOWN.	a.m.	a.m.	p.m.	p.m.	p.m.	p.m.
Grayshott ..depart	9 20	1145	2 30	..	5 25	6 50
Huts Hotel .. ,,	9 30	1155	2 35	3 42	5 35	6 55
Nutcombe Lane.. ,,	9 40	12 5	2 40	3 50	5 40	7 0
Shottermill Church ,,	9 45	1210	2 45	3 55	5 45	7 5
Haslemere Station ,,	9 50	1215	2 50	4 0	5 50	7 10
Haslemere Town Hall ar.	10 0	1220	2 55	4 5	5 55	S
UP.	a.m.	p.m.	p.m.	p.m.	p.m.	p.m.
Haslemere Town Hall dp	1015	1240	3 0	4 15	6 0	S
Haslemere Station ,,	1020	1250	3 10	4 25	6 10	7 42
Shottermill Church ,,	1025	1255	3 15	4 30	6 15	7 45
Nutcombe Lane ,,	1028	1258	3 18	4 33	6 18	7 50
Huts Hotel .. ,,	1035	1 10	3 32	4 40	6 30	8 0
Grayshott .. arrive	1040	1 15	..	4 45	6 35	8 5

S, Wednesdays only. Daily during summer.

These Buses call outside the Station on up journey, except the 7.42 p.m., which starts from the Station.

FARES BETWEEN

Haslemere and Grayshott	8d.
Hindhead and Haslemere	6d.
Hindhead and Shottermill Church	4d.
Nutcombe Lane and Haslemere Station	..	3d.
Nutcombe Lane and Hindhead	3d.
Haslemere Station and Shottermill Church	2d.
Hindhead and Grayshott	2d.
Railway Station and Town Hall	1d.

Luggage: 2d., 3d. and 4d., according to size of parcel.

Every Wednesday a Special Bus leaves Grayshott at 10.5, running through Tower Road, Churt Road, and Wood Road, leaving the "Royal Huts" at 10.20, to catch the 10.55 Excursion Train to London.

THE BUS SERVICE from Haslemere railway station to Hindhead and Grayshott in 1911 was advertised in the local guidebook. The service, operated from the Royal Huts Hotel by Mr Ben Chandler (see p. 49), was taken over by the Aldershot & District Traction Company in October 1913.

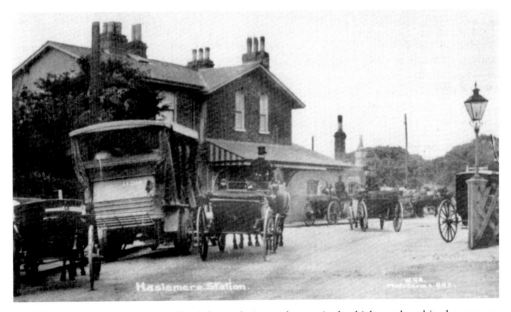

AROUND 1910 a wide variety of both horse-drawn and motorised vehicles gathered in the entrance yard to meet passengers from the next train to arrive at Haslemere station. The motor vehicle was a Thoneycroft bus owned by the London & South Western Railway Company who provided a route from Haslemere to Farnham.

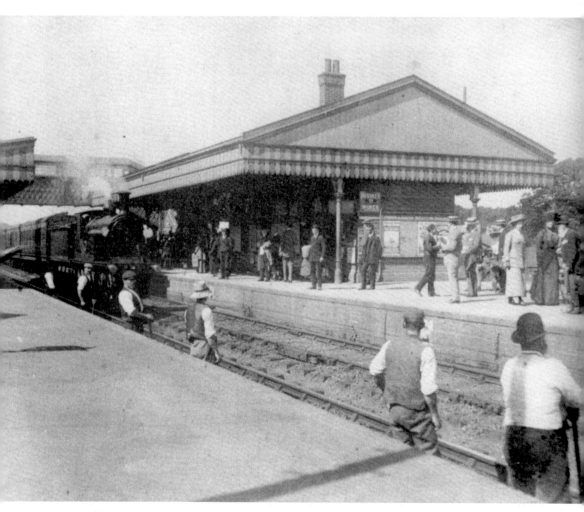

THE SCENE AT HASLEMERE STATION around 1910 as passengers wait to board the London &
South Western Railway Company express that is approaching from Havant. By this time services to
Woking had greatly improved since the four trains per day each way when the line opened in 1859.
However there was no significant increase in the number of trains from the beginning of the century
until the line was electrified on 4 July 1937. From this time weekday service increased to one fast and
two slow trains per hour and journey times were much improved. The railway had its greatest effect on
the growth of the town and the surrounding area when this regular service to London became available
and people were able to commute to the capital. When this picture was taken the LSWR were still using
their distinctive two-tone paintwork around the edge of the canopy, which at this time did not extend
south beyond the footbridge, but this colouring was to disappear after the 1923 regrouping when the
London to Portsmouth line became part of Southern Railway.

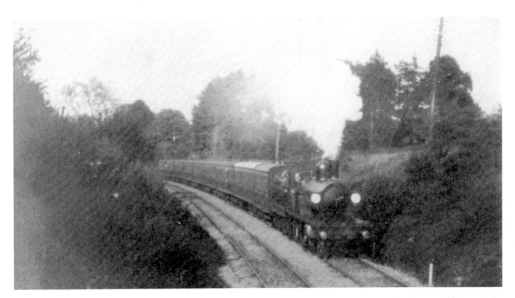

A SOUTHBOUND London & South Western express train approaching Haslemere station through the cutting before the bridge in Tanners Lane.

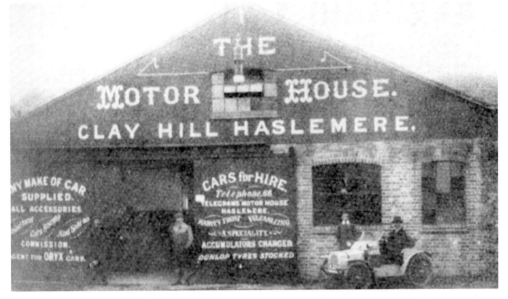

THE OWNERS OF MOTOR CARS in Edwardian Haslemere were offered private lock-up cubicles in which to keep their vehicles by Mr C. R. Nash-Wortham at the Motor House, Clay Hill. The garage was purchased by the Aldershot & District Traction Company in April 1914 and by 1916 was advertised as the Clay Hill Garage (see p.136). The building was only high enough for single deckers so a second garage suitable for double deckers was added in 1925. The opening ceremony was marred when a party of Aldershot & District directors watched in shocked disbelief as a driver took his double decker into the old single deck garage by mistake. When the new bus garage opened at Hindhead in 1931 the old premises were acquired by Clement Brothers for the manufacture of windows. Demolition started in 2009.

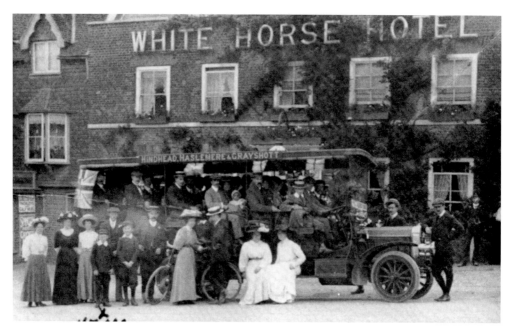

GRAYSHOTT PHOTOGRAPHER J. P. WALDER was in Haslemere on 1 August 1910 to photograph this excursion about to leave from outside the White Horse for a day at Brighton. Sitting in the Dennis charabanc and wearing a straw boater is seventeen-year-old Ernest William Read (third from left) who later became manager of the Beacon Hill Stores founded by his father James (see p.65).

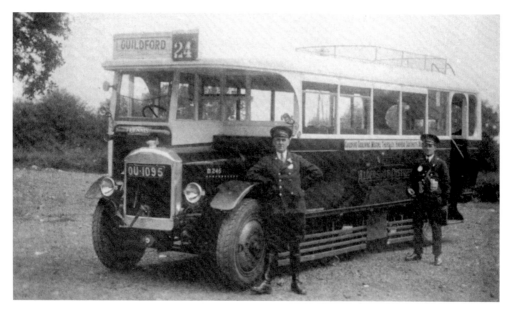

ALDERSHOT & DISTRICT bought eighteen E-type single deck buses in 1929 that carried thirty-one seated passengers. OU 1095 was used until 1936 on the route from Guildford to Bramshott via Godalming, Milford, Thursley, Hindhead and Grayshott. This bus was last known in 1952 when it was at a fairground in Northampton.

SECTION THREE

Hindhead and Beacon Hill

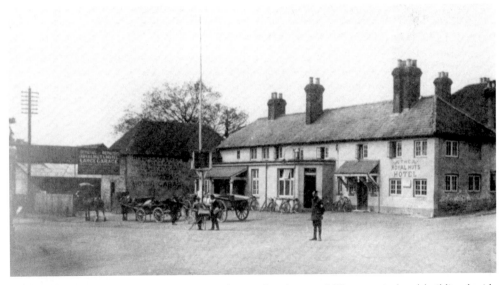

THE ROYAL HUTS, once Hindhead's best-known hotel, started life as an isolated building beside the Portsmouth Road where coachmen fed and watered their horses before continuing their journeys across the inhospitable countryside. Whortleberries collected from the heathland were sent from there to London, where they were used for dyeing. William Cobbett, who did not like Hindhead and always tried to give it a wide berth, wrote in November 1822 that he came across the turnpike near the 'buildings called the Hut'. The landlord then was a Mr Lawrence, and around that time the inn was badly damaged by fire. John Ellistone, from Suffolk, was the next publican, and the last to brew his own ale, and when he left to take over the Three Horseshoes at Thursley in 1893, Ben Chandler, who was in the brewing trade, became 'mine host' and took the hotel into the twentieth century by catering for the motor car. He was also the founder of the Hindhead Motor Works and began a bus service between Grayshott and Haslemere. The hotel became a Little Chef restaurant before the site was cleared and houses were built, but older residents continue to refer to the crossroads area as 'The Huts'.

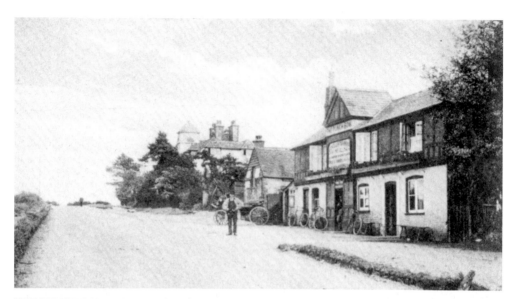

THE PUNCH BOWL INN may have been seventeenth century, and at one stage was a temperance house. It was sold in 1944 by order of the Hon. Rollo Russell Trust, along with sixteen cottages in Tilford and Grove Roads, Beacon Hill, two houses in Haslemere, and a house and building plot in Hammer, for a total of £11,045. When it was demolished to make room for a petrol station, its name was transferred to the Thorshill, visible in the background, which became know as the Devil's Punch Bowl Hotel.

THE GROUP OF BUILDINGS at Hindhead crossroads, which included Nutcombe Head, was developed by Walter Rollason. His wife Kate ran Nutcombe Head for many years while he conducted his business in the adjoining post office stores which he owned, along with tea rooms in London Road. He retired in 1929 after twenty-two years as postmaster. The post office returned to the corner shop after many years in purpose-built premises beside Nutcombe Head, but is now in Royal Parade, Tilford Road.

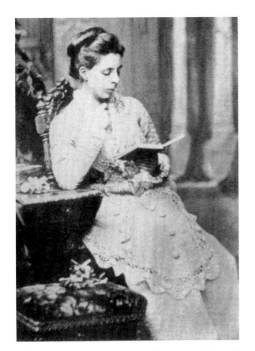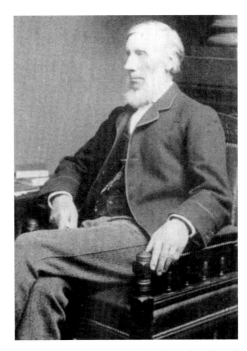

PROF. JOHN TYNDALL, born in 1820, the son of a small landowner in Ireland, had achieved greatness as a scientist and a mountaineer by the time he discovered Hindhead in the early 1880s. His love of Switzerland – in 1860 he was one of the first to climb the Matterhorn – took him and his wife, Louisa, to the Alps each year. But when ill health prevented him from travelling abroad, the couple came to Hindhead and, while living in a hut (just visible below), built Hindhead House 'four square to all the winds of heaven'. Tyndall died in 1893 from a fatal overdose administered accidentally by his wife, who remained at the house until her death at the age of ninety-five in 1940.

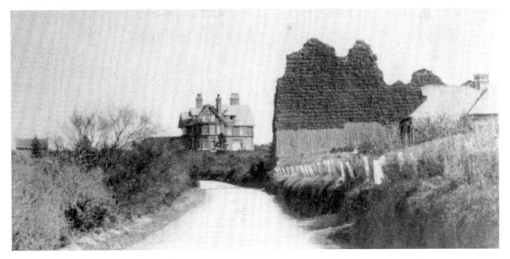

HINDHEAD HOUSE is now flats on an estate bearing the Tyndalls' name. The screen was an attempt to provide privacy which *Punch* called Tyndall's Folly. It was toppled by gales in 1901.

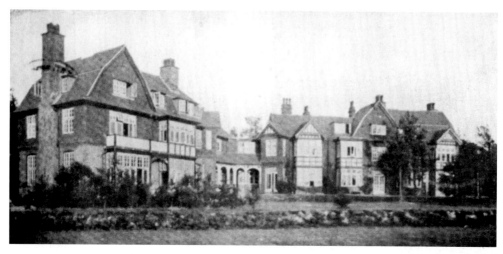

THIRLESTANE started life as a private house, became an hotel and is now flats. It was built in the 1890s for Mr W. Biscombe Gardner, an artist, but by the turn of the century was an hotel run by Mr H. L. Crisp and his two sisters. When it was put on the market in 1938 it had thirty-six bedrooms. It was not sold and was taken over by a London insurance company during the war. In 1948 it was sold to a London housing company for around £28,000.

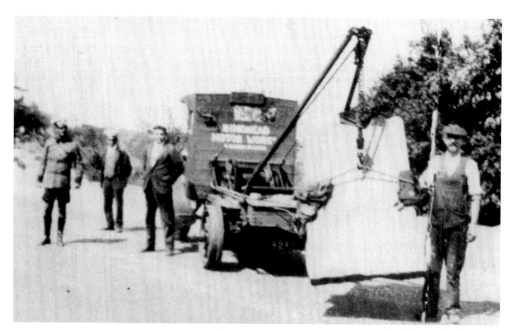

'CURSED BE THE MAN WHO INJURETH OR REMOVETH THIS STONE' warns an inscription on this famous memorial at Hindhead. It commemorates the murder in 1786 of a man referred to only as the 'unknown sailor'. This 1932 photograph shows the stone being righted after vandals had pushed it over. It was moved again in the 1940s to its present position high above the Devil's Punch Bowl bend on the A3. The curse? The driver of the Hindhead Motor Works Dennis breakdown lorry, the late Mr 'Joe' Johnson, when eighty-eight, did not believe a word of it. But he did admit that he had not touched the stone!

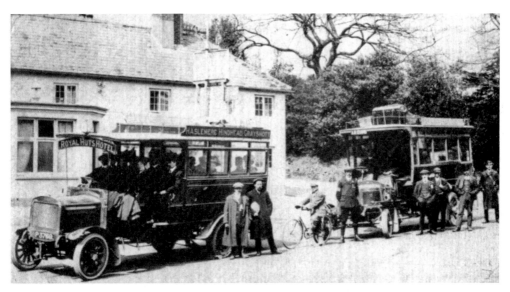

BUSES AT THE ROYAL HUTS HOTEL around 1909. The landlord Ben Chandler's twenty-eight-seater Commer car saloon (left) was described as an 'indispensable adjunct to a first-class hotel'. The London & South Western Railway's Thorneycroft sixteen-seater bus operated on the route between Farnham and Haslemere. Both services were bought out in 1913 soon after the Aldershot & District Traction Company was founded. The man standing in front of the bonnet of the Thorneycroft was the first AA patrol to work the Portsmouth Road at Hindhead.

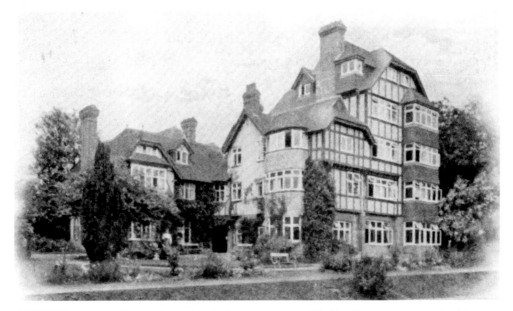

GLEN LEA was one of a number of hotels that sprang up as Hindhead's popularity as a health resort grew. Perched high about Nutcombe valley, it was owned by Mr John S. Ward for many years. He had moved to the district in 1884 and was also an estate agent. Glen Lea continued to be an hotel after the Second World war, but was eventually demolished.

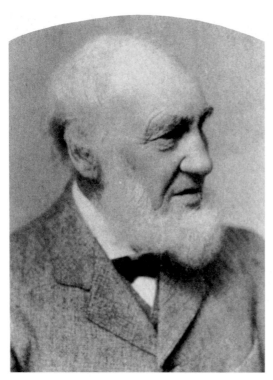

CHARLES BRIDGER founded the estate agency business of C. Bridger and Sons in 1858, and was a pioneer in the accommodation field in the district. He also purchased land for development and one of his acquisitions was the 45-acre holding at Hindhead of the future prime minister, Arthur (later Lord) Balfour. The land was adjacent to that of Prof. Tyndall (see p. 51) and was surrounded by a fence to keep out trespassers who were threatened by notices warning of 'pains and penalties of all kinds', Bridger subsequently sold the land to John Grover (see p. 60).

THE HON. ROLLO RUSSELL (1849-1914) was the third son of Lord John Russell by the Victorian prime minister's second wife. He was the uncle of the philosopher Bertrand Russell, and sister of Lady Mary Agatha Russell; who was a child favourite of Queen Victoria. Both brother and sister were developers and landowners in the district, and Rozeldene estate at Hindhead was built on the site of the sister's home of the same name which she had commissioned in 1904. Russell's lasting memorial in Hindhead is the Devil's Punch Bowl Hotel which he built as the Thorshill Pension (see p. 58) just before the turn of the century.

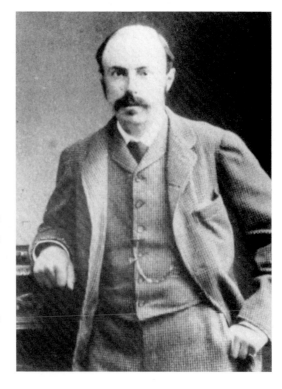

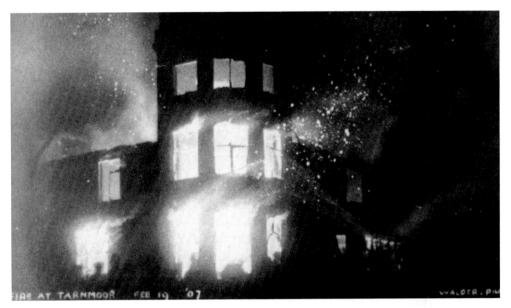

THE FIRE that destroyed Tarn Moor mansion at Hindhead in February 1907 burned for five hours. Built by Frederick Jackson, a retired London solicitor, ten years earlier, the house, which was valued at around £15,000, was a treasure trove of pictures, china and furniture, plus a magnificent organ, also built by Mr Jackson, which was to have been inaugurated at a concert in the house that very evening. The blaze was accidental but Mr Jackson did have local enemies who were thought to have started an earlier fire which destroyed a stable block and horses. The house was rebuilt and later became a school and is now a nursing home.

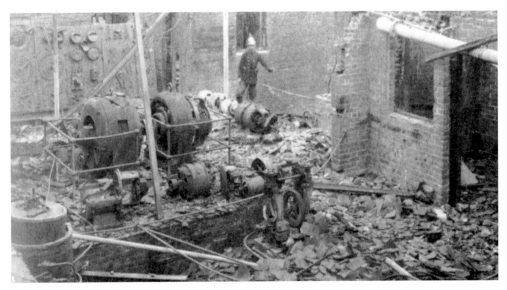

ALL THAT WAS LEFT of an electricity sub-station in tower road after a fierce fire in 1909. Grayshott and Hindhead Fire Brigade did its best to contain the blaze at the building behind the Moorlands hotel. The brigade was formed in 1906, five years after the Hindhead and District Electric Light Company.

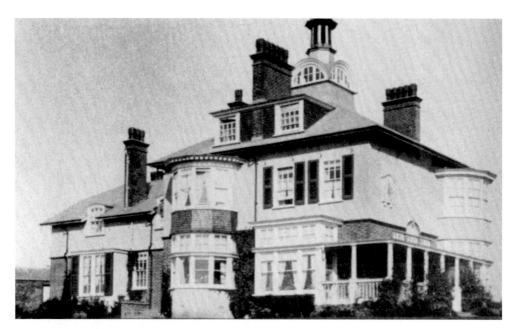

HIGHCOME EDGE is now a school run by the Plymouth Brethren, having once been owned by Lloyds Bank and later the Guide Dogs for the Blind Association. Built in 1897 by Mr Rayner Storr, an auctioneer, with nine bedrooms and four bathrooms, it was set in forty-four acres. Mr Storr (1835–1917) was for ten years the secretary of the Haslemere Microscope and Natural History Society. Highcombe Edge was later owned by Viscount Exmouth, a distinguished chemist who in 1923 had returned from America to succeed his father as the seventh viscount. He and his wife, who both died in the 1940s were generous benefactors.

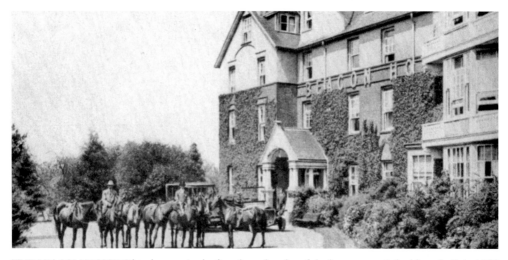

THE BEACON HOTEL'S heyday was in the first three decades of the last century. It had been built in 1898 and £20,000 was spent on buying 15 acres of land and erecting and furnishing the premises. The Beacon, with its own livery stables and riding school, was advertised widely as a high-class hotel, with 'first-rate wines and cuisines.' It stood on the 'choicest site on the heather-clad hills' and the district was 'highly recommended as a health resort at all seasons.' It became a training centre for Lloyds Bank but has now been demolished and replaced by a gated complex of new houses and apartments built on the site of the old hotel.

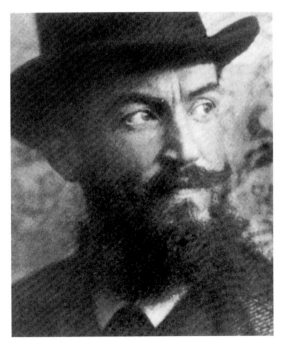

MENTION THE NAME George Bernard Shaw and an elderly gentleman with a white beard probably comes to mind. But this was how the great writer appeared when he lived in Hindhead at the turn of the last century. Shaw and his wife spent their honeymoon in 1898 at Pitfold House, Woolmer Hill, and later rented Blen-Cathra, an imposing house on the Portsmouth Road, which is now St Edmund's School. Shaw was much in demand to attend this function or speak at that event, but he soon tired of the country and returned to London.

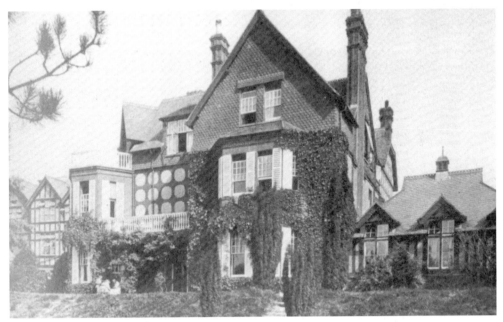

ST EDMUND'S SCHOOL, now in its second century in Hindhead, was founded 135 years ago in Norfolk. The founder's son, Cyril Morgan-Brown, brought the school to Blen-Cathra in 1900 and transformed the Victorian former home of G. B. Shaw into a vibrant preparatory school for boys. Morgan-Brown, wrote R. C. Robertson-Glasgow, old boy-cum-teacher, was 'the wisest and the simplest man I have ever known'. Robertson-Glasgow, also a distinguished cricket writer and player, wrote his autobiography, *46 Not Out*, in 1948 and included reminiscences and anecdotes from his time in the district.

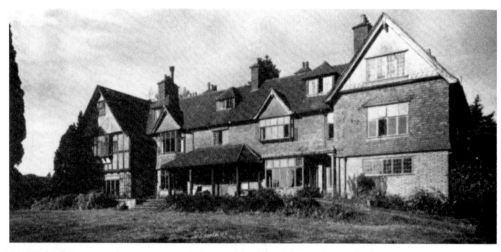

HONEYHANGER on Hindhead Hill was built in 1893 by the Liberal politician Charles Benjamin McLaren who, in 1911, became the first Lord Aberconway. Among its early residents was the publisher, Sir Algernon Methuen, and later Sir Henry and Lady Norman lived there. Their gardener for twenty-seven years, Mr James Belton, and his wife Jane had lived in the area since the 1860s. The house was sold in 1946 for £7,500, and the new owner, the Revd J. Aubrey Moore, ran it as a private hotel.

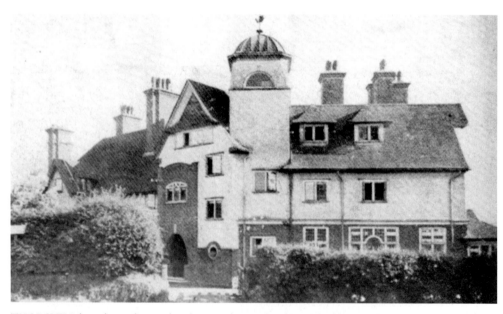

THORSHILL has always been a hotel, apart from a brief period after it had been designed and built by the Hon. Rollo Russell (see p. 54) as his private residence. The first and longest-serving proprietors of what is now the Devil's Punch Bowl Hotel were the Revd Alfred Kluht and his wife, who bought the premises from Russell in about 1884 after ill health had forced him to retire from the Congregational ministry in Essex. The Kluhts arrived before the crossroads were developed and the area was a tangle of gorse, broom and heather-clad fields. They ran a wagonette between the hotel and Haslemere station. Mr Kluht assisted in the formation of the Congregational church in Tower Road.

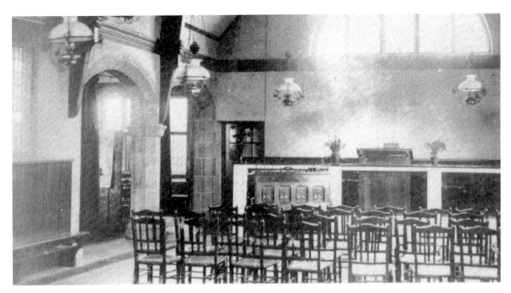

THE UNITED REFORMED CHURCH in Tower Road, as it appeared shortly after its construction as the Congregational Hall in 1896. The first service was held on Sunday 9 August, by the superintendent minister, the Revd George Stallworthy, who had previously served in Haslemere. In 1900, the church's benefactor, Mr John Grover, completed the building of a school hall and a manse, and the original hall became known as the Hindhead Free church. It quickly became a focal point in a growing community, and apart from services, was the venue for a varied programme of lectures and meetings.

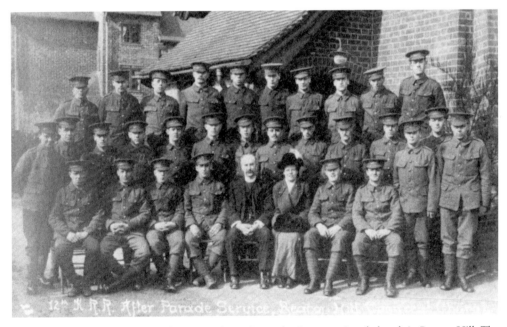

THIS 1915 GROUP was taken after a parade service at the Congregational church in Beacon Hill. The church had been provided ten years earlier by John Grover. The 12th King's Royal Rifles was a service battalion which was disbanded after the war.

JOHN GROVER (1835-1913) was a prominent Hindhead developer at the turn of the century. He came to the district in 1895 when he was sixty and effectively started the second chapter of his career. His first in London had many milestones and his lasting monument is New Scotland Yard. In Hindhead he built the Moorlands Hotel on the Portsmouth Road, the Nonconformist church in Tower Road and many large houses. He lived at Heatherbank, Tower Road, which was later the home of Marie Stopes, the family planning reformer. Mr Grover also developed the brickworks at Hammer (see p. 150).

EARLY DEVELOPMENT in Wood Road included the Highcroft Hotel. John Grover was responsible for much of the growth of the road from about 1902, and Grover's Garden is a present-day reminder of this great benefactor. Two neighbouring properties, Woodberry and Wilton, which subsequently became private hotels and much later were linked and converted into a nursing home, were so named to remind him of his former London home in Woodberry Down, Finsbury Park, and his business premises at Wilton Works, Islington.

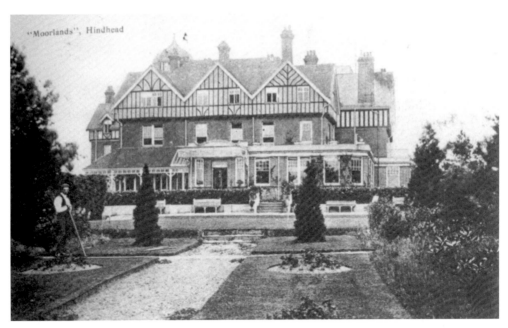

"Moorlands", Hindhead

MOORLANDS was John Grover's first major undertaking after his move to Hindhead. It was built in 1895 and was, like the Beacon across the Golden Valley, a prestige resort hotel that attracted royalty and nobility to sample its comfort and its fine cuisine and wine. It did not return to its former glory after being requisitioned during the Second World War, and in 1952 Lloyds bank added it to its training centres in Hindhead. Subsequently, it was converted into offices and, sadly, the name was changed.

HOTEL MOORLANDS, HIND HEAD.
1906.

No charge for Attendance or Electric Light.

APARTMENTS.

		PER DAY—s. d.	
Single Bed Rooms	..	from	5 6
Double ,, ,,		8 0
Sitting Rooms ,,		12 6

Extras.

Cot in Bed Room	per day	1 0
Early Tea	,,	0 6
Breakfast in Bed Room	,,	0 6
Meals served in Private Rooms	,,	1 6

Baths.

Hot or Cold in Bath Room	1 0
Hip Bath in Bedroom	0 6

Fires.

Fire in Bed Room or Sitting Room	1 6
Evening Fire in Bedroom after 5 p.m.	1 0

Dogs.

Charged from 7/- per week and are not allowed in the Public Rooms.

Visitors' Servants.

Board	per day from	5 0
Bed Room..	..	,,	,,	2 6

Table d'hote.

		Resident		Non-Res.
Breakfast 8.30 to 9.30	..	2 6	..	3 0
Luncheon 1.0 to 2.0	..	2 6	..	3 0
Dinner 7.30 p.m	..	5 0	..	6 0
Afternoon Tea	..	1 0	..	1 0

Inclusive Tariff.

BOARDING TERMS—
From November to March,
3½ to 6 Guineas per Week.
From April to October,
4½ to 8 Guineas per Week.
According to Rooms.

includes Table d'hote Breakfast, Luncheon, Tea, Dinner, and Bed Room.

Visitors requiring Boarding Terms should give notice on arrival

Sitting Rooms from 3½ Gns. per week.

Suites, consisting of Sitting Room, two or more Bed Rooms, private Bath Room.
Terms on Application

A 1906 TARIFF CARD available on request from the manager, Moorlands Hotel, or by telegram to Moorlands, Hindhead.

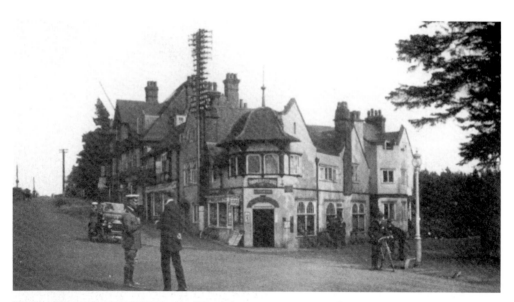

THE MOTLEY COLLECTION of buildings that comprises Post Office Corner on the crossroads was the business base of the Rollason family for more than fifty years. Walter Rollason, a Londoner, and his wife Kate, the daughter of an Oxfordshire police superintendent, settled in Hindhead in 1897 and lived in an old cottage, now a restaurant, beside the post office. The Rollasons lived at Homefield, Tilford Road, for twenty years before they died, thirteen days apart, in 1954. His nieces, the Misses E. and D. Rollason, ran the corner shop from 1934 until they retired through ill health in 1952. The old post office was demolished in October 2001.

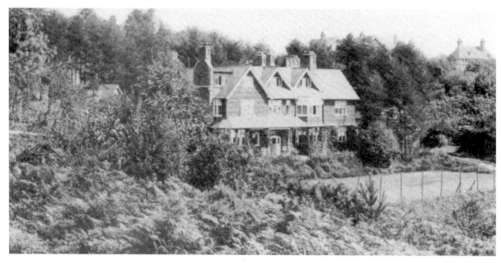

UNDERSHAW, now a shadow of its former self, was built in 1896-7 for Arthur Conan Doyle, and he and his family lived there for about ten years. It was at Hindhead that he revived his great character, Sherlock Holmes, the detective whom he detested but the public loved. Sir Arthur, who was knighted in 1902, was involved in local events, and as a sportsman played cricket for Grayshott, shot with his own club, and supported the first Hindhead footballers, who were taught the laws of the game by Ben Chandler, 'mine host' of the Royal Huts Hotel, and Conan Doyle using the latter's billiards table as a model pitch.

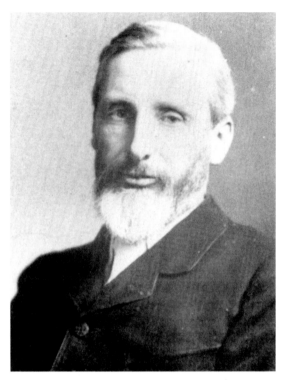

GRANT ALLEN (1848-99) was a Canadian writer who came to Hindhead in 1893 and built The Croft in Tilford Road on the edge of the Devil's Punch Bowl. His book, *The Woman who Did*, written in 1895, was about social and sexual problems, and caused a good deal of controversy. The rector of Haslemere opposed Allen's bid for the presidency of the Haslemere Microscope and Natural History Society the following year, but the author won the ballot by two votes from Prof. Alexander Williamson, a distinguished scientist who lived at nearby Pitfold.

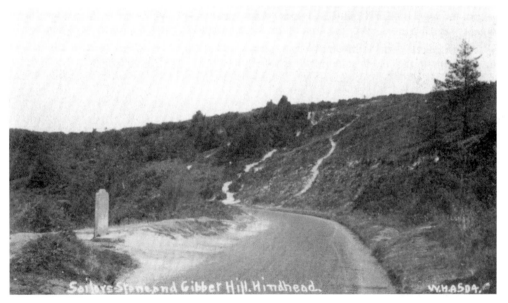

THE SAILOR'S STONE behind the A3 some years before its removal to its present position beside the old Portsmouth Road. The stone, which was donated by James Stilwell of Cosford, Thursley, originally stood higher on Hindhead and closer to the spot where the 'unknown sailor' was murdered, and was brought to its lower site when the new road was carved out of the hillside in 1826.

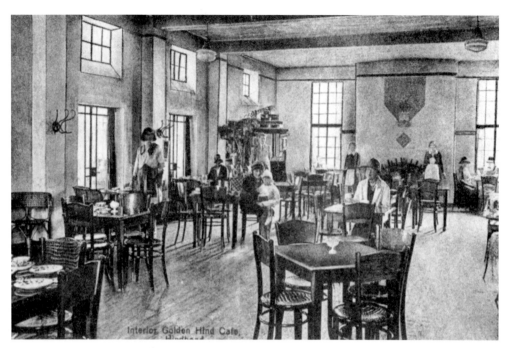

Interior Golden Hind Café, Hindhead.

THE GOLDEN HIND CAFÉ on the A3 was a big attraction for visitors to Hindhead when it was fashionable to drive out into the country for afternoon tea. But it was not always a successful enterprise, and the first proprietor told a bankruptcy court in 1932 that two wet summers had caused her demise. She had built the café and adjoining house for £2,700, having bought the land for £900, and had opened for business in 1930 in time for Easter. Now a second-hand business, the post, that once had a replica of Drake's galleon swinging from it, still stands, and the sign is still visible.

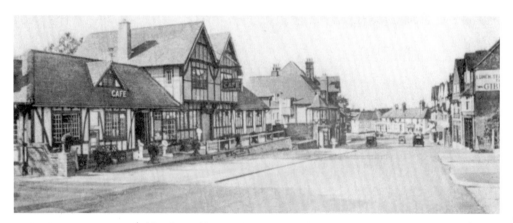

THE SALLY LUNN CAFÉ, like the Golden Hind opposite, was a place to rendezvous and stop awhile in the days when travel seemed to be more relaxed. It was well known for its food, and a telephone call to Hindhead 30 would reserve a place for a 'good Sally Lunn tea, a comfortable chair, a pleasant chat and one and half hours of talking pictures'. The café was at first single storey, and was probably enlarged after it was offered for sale in 1931 with the neighbouring private hotel called Brackenhurst. There are now flats on the site.

JAMES HENRY READ and his wife Blanche, pictured outside their shop in 1906 with their son, Ernest William, and daughter, Nellie (centre), and a friend. James, a butcher, and Blanche, a maternity nurse, came to Beacon Hill in 1902 and opened the village's first shop on the corner of Tilford Road and Beacon Hill Road. Mr Read died in a road accident in Hindhead in 1920, and was survived by his wife for twenty-seven years until she passed away aged ninety-two in Heatherbank Nursing Home, leaving three sons, three daughters, nineteen grandchildren and twenty-three great grandchildren, some of whom continue to live in the village.

BEACON HILL ROAD looking south-west. This 1910 view clearly shows the barren landscape before the developers took over. The empty spaces are now built on and children no longer play in the road!

SELWYN FRANCIS EDGE, who was born in Australia and brought to England at the age of three, became the biggest name in early twentieth-century competitive motoring. He was a Brooklands ace who held numerous speed and endurance records (he was a champion cyclist, too). By the time he came to live in Corry Road, Beacon Hill, he had diversified into farming and landowning, had established the largest pedigree pig-breeding business in the country, and had helped to introduce the farm tractor to Britain. The life of this AA pioneer ended in 1940 when he fell through a hotel window.

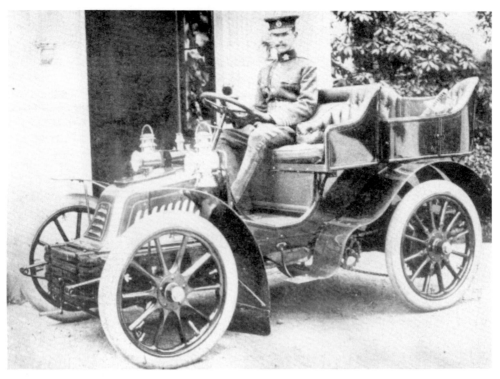

LIEUTENANT COLONEL MARK MAYHEW was a pioneer motorist who moved to Beacon Hill and became a near neighbour of an even more famous motoring name, S. F. Edge. For three years, he had lived at Bookhams, Churt, and he retired to The Wilderness, Churt Road, and became a prominent member of Hindhead and Churt British Legion, which in those days met in the Woodcock Inn. Mayhew was a member of the first executive committee of the AA and was a vice-chairman of the RAC.

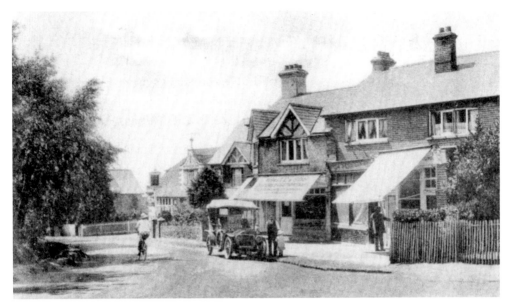

THIS NINETY-YEAR-OLD VIEW of the junction of the A287 Churt Road and Beacon Hill Road is easily recognisable today. The car stands outside the shop that for nearly forty years was a men's hairdresser, and beyond it is the distinctive frontage of the Woodcock Inn, built by the Surrey Public House Trust in 1916 and for almost twenty years the headquarters of the local branch of the British Legion.

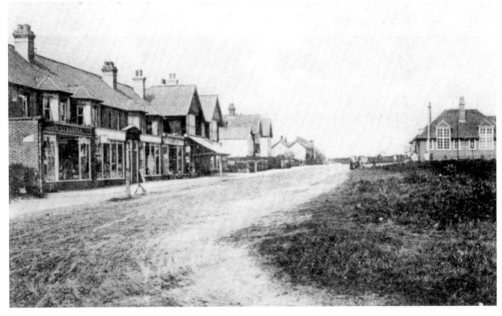

BEACON HILL ROAD in 1909 from its junction with Churt Road is still recognisable in spite of the infilling that has occurred. The school, on the right, was built in 1906 by the Frensham firm of A. Chuter and Son, and the shops were developed by Walter Rollason of Hindhead, who had bought the properties which had become known as the 'slum of Beacon Hill'.

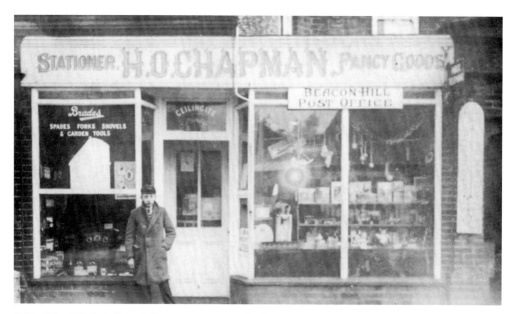

HAROLD OLIVER CHAPMAN was Beacon Hill's first sub-postmaster in 1907, and ran the business until he retired in 1950. The family moved to Grayshott from London in 1892 and his father, who was the organist at St Luke's, Grayshott, for forty years, ran the post office in that village. H. O. Chapman played a major role in Beacon Hill getting street lighting in 1922.

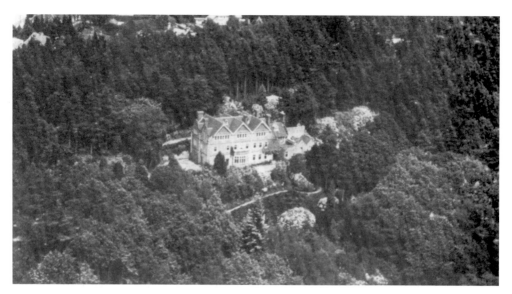

WHITMORE VALE HOUSE, built by Edgar Leuchars of Grayshott just before the turn of the century, was bought by the Co-operative Holidays Association in 1934 and run as a guest house. It is now a residential home.

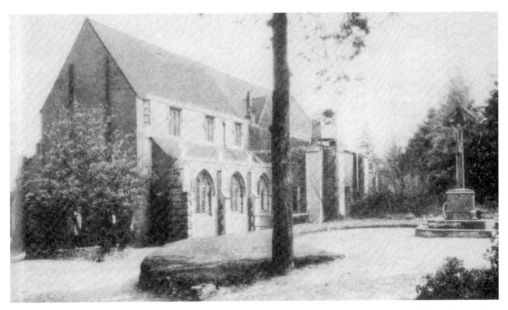

HINDHEAD'S PARISH CHURCH was consecrated in 1907, and the parish of St Alban's formed at the beginning of the following year. The first meeting to discuss a church on land provided by Lord Ashcombe, the Lord Lieutenant of Surrey and the then owner of much of Hindhead, had been held in October 1899. For two years before the church was built worshippers met in an iron mission hut. Original plans for a church tower were abandoned in 1920.

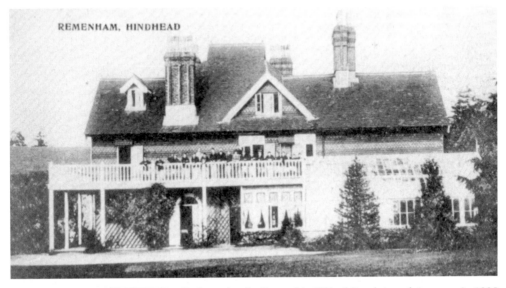

REMENHAM was one of Hindhead's first schools. Situated in Tilford Road, it took its name in 1905 from a Thames-side village near Henley where the new owner, Robert Everard, had lived. He took over a school founded on the site of an old farmhouse known as Trimmer's Wood in 1893 by Edward Turle, who was a great Hindhead figure for forty years. Later, the building became the Manor Hotel, and its core now forms part of a private house on a small estate named after the Victorian farmstead.

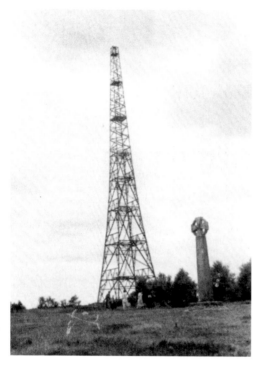

FOUR MASTS dominated the Hindhead skyline during the Second World War. They were associated with an RAF radar station on Gibbet Hill which was one of a network of communication bases in the country. The wooden masts were 250 ft high, and this one, adjacent to the Celtic cross near the site of the celebrated Hindhead murder of 1786, was the last to be removed in 1958. Another was partially destroyed in 1945 when an American transport Dakota crashed into it in bad weather with the loss of more than thirty passengers and crew, plus a Canadian serviceman at the base.

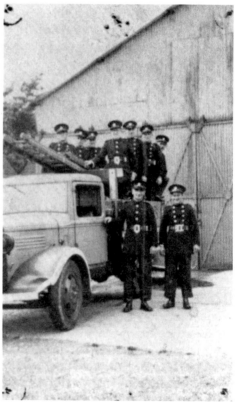

BEACON HILL'S AUXILIARY FIRE SERVICE during the Second World War was stationed in a large hangar-like shed on Churt Road, below the Woodcock Inn, and in front of the present-day St Anselm's Catholic church. Few bombs dropped on Hindhead, but the alarm was sounded often as enemy planes came in over the Channel and fixed their sights on the military camps at Aldershot. The men of the AFS worked by day, some for Haslemere Urban District Council whose Bedford lorry had been requisitioned, and manned the station, which was also used to store a Dakota aeroplane, by night.

SECTION FOUR

Grayshott

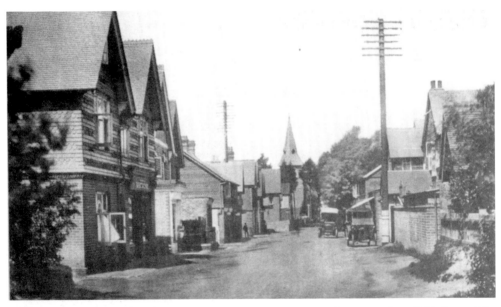

GRAYSHOTT'S EXISTENCE owes much to the thrust and drive of Mr A. Ingham Whitaker and Dr and Mrs Arnold Lyndon. They were responsible for much of the early growth, and Crossways Road, which used to be called Hindhead Road, was developed early. Mr and Mrs Henry Robinson, who had traded at Mount Cottage in the early 1870s, moved to Crossways Road in what was then referred to as Upper Grayshott in 1877 and built a shop which, ten years later, became the post office. After Henry's death, his widow, Hannah ('Granny'), continued to run the business, and as one of the oldest residents, planted a yew tree in the children's recreation ground to mark the Coronation of King George V in 1911. The importance of Crossways Road to the life-blood of the village continues today.

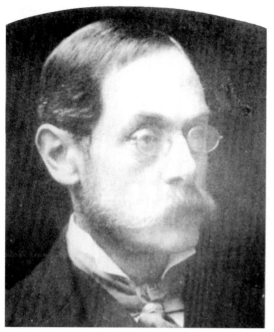

SIR FREDERICK POLLOCK came to Hindhead in 1884 and succeeded his father as the third baronet four years later. He built Hindhead Copse, which is now part of the Grove School, and took an active role in local affairs, including the Haslemere Microscope and Natural History Society, the Shottermill Working Men's Club, of which he was a founder, the Grayshott and District Refreshment Association, which built the Fox and Pelican public house, and the Surrey Public House Trust Company. He left the district in 1904 when he decided that Hindhead had already lost its remoteness and charm to the developer. Sir Frederick was an eminent jurist who, shortly before his death in 1937, advised on the form of the Abdication Act.

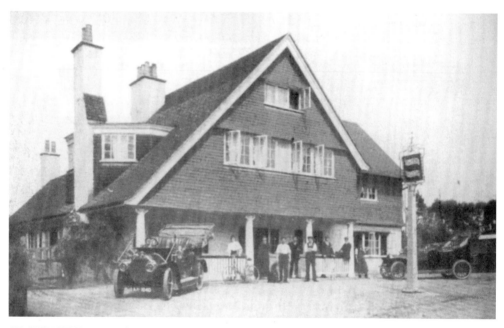

GRAYSHOTTS PUB is the Fox and Pelican whose origins and name are interesting. It was opened in August 1899, a year after the Grayshott and District Refreshment Association was formed with the purpose of establishing a public house. The name recalls the founder of Corpus Christi College, Bishop Fox of Winchester, whose emblem was a pelican. The link was the GDRA chairman, Sir Frederick Pollock, who was attached to Corpus Christi and lived at Hindhead Copse. The pub was opened by the wife of the then Bishop of Winchester, Dr Randall Davidson.

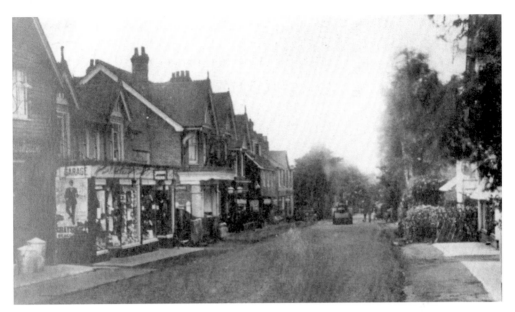

HEADLEY ROAD is Grayshott's main thoroughfare and takes traffic to and from the A3, and like Crossways road it crosses the county boundary. There have been many changes during the time since the layout of Grayshott began, but basically it remains a village that can provide for every occasion and requirement. Once, perhaps when Prof. Tyndall was establishing Hindhead as a popular health resort, Grayshott was something of an adjunct, but no longer and Hindhead residents rely heavily on their Hampshire neighbour for everyday needs.

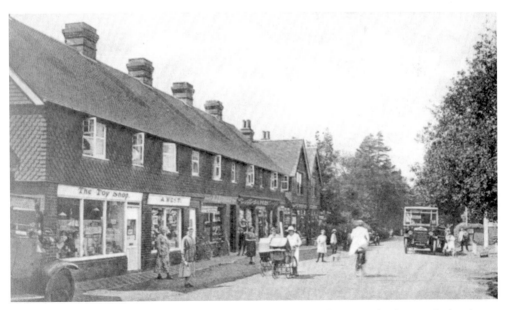

HINDHEAD TERRACE in Headley Road was situated opposite the Fox and Pelican and when it was built it comprised four businesses: a grocery and Drapery run by Mr and Mrs Cornish, Mrs Hart's sweet shop and a butchers run by Mr Sayers.

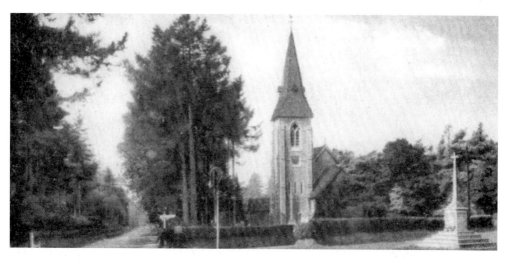

THIS SCENE DISAPPEARED in 1932 when the war memorial at Grayshott was moved to its present position at the junction of Headley and Crossways Roads. The York stone memorial was erected at a cost of £400 and unveiled and handed over to the parish council on 17 July 1921. But the village green was a windswept area and one councillor described the site as 'just a dark cross in the middle of a field surrounded by scraps of paper, cigarette boxes and other refuse'. Eleven years after it had been unveiled, the memorial was moved to the corner of the children's recreation ground where it has remained.

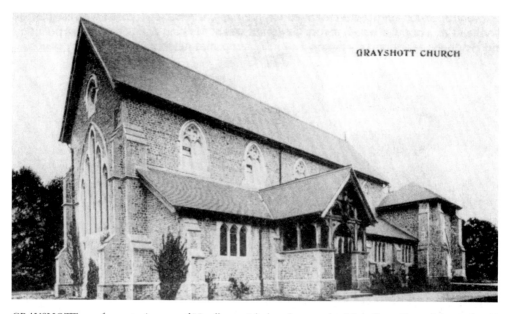

GRAYSHOTT was for centuries part of Headley parish, but the growth of the village dictated that it should have its own boundaries and church. Services had been held in the school and in an old dame school at the junction of Kingswood Lane and the Portsmouth Road. However, in the 1890s there was a move to build a parish church, and when an appeal fund had reached £4,000 the foundation stone was laid on 3 September 1898, by Miss Catherine l'Anson. The church was dedicated to St Luke, although St John the Baptist had been suggested, and the final cost was £5,161 18s. 11d. The first service was held on 17 October 1899.

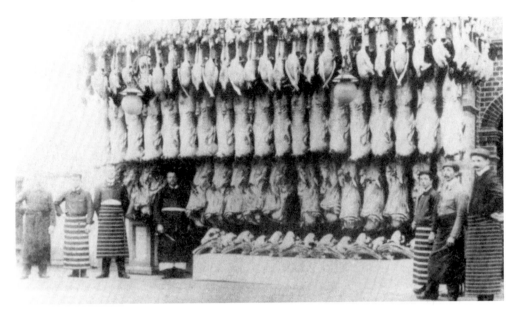

A FINE DISPLAY of meat and poultry outside Mitchell's shop in Headley Road. Mr Mitchell is in the doorway, George Peskett on the extreme right with William Frogley to his immediate left – who mentioned public health? With the many large houses, hotels and schools to be supplied, Mitchell's business boomed and he employed quite a number of butchers who both cut and delivered the meat. By 1913 it was so successful that it became H. Mitchell & Company. However, by 1920 another butcher, James Grimditch, was supplying meat in the village.

ONE OF H. MITCHELL'S MEAT DELIVERY CARTS pictured at the annual parade on Philips Green. These carts, with their drivers dressed in the traditional butcher's aprons, must have been a familiar sight delivering meat around Hindhead and Grayshott before the First World War. Mr Mitchell claimed in a 1911 advertisement that orders for meat received by the first post would be delivered before 11 a.m. the same day.

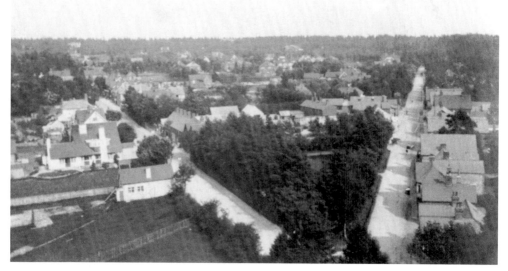

JAMES WALDER was the photographer in Grayshott during the first three decades of this century. His studio was in Headley Road about where the Co-op food store now stands. Around 1910 he ascended the spire of St Luke's church and took a series of interesting panoramic views of the village which he then sold as postcards.

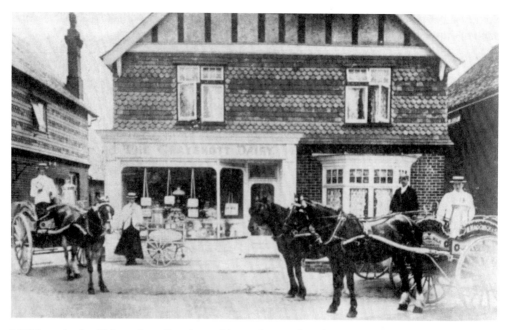

MILK was in plentiful supply at Grayshott with two dairies, the White Heather Dairy in Headley Road, and in Crossways Road the Grayshott Dairy. This was operated by H. Madgwick & Son who also had a branch at Beacon Hill. Around 1910 milk was not bottled but delivered from door to door in large slope-sided churns, the movement of the carts ensuring the cream did not settle out. A pail was filled from the churn and the milk measured out for the housewife with a metal ladle.

SECTION FIVE

Sport and Entertainment

Hindhead, Golf House.

TEEING OFF at the first at Hindhead. This period shot was taken soon after the golf course had been opened in 1904. Edward Turle, secretary for the first eighteen years, planned the course, and a great professional of the age, J. H. Taylor, laid it out on 143 acres of Lord Ashcombe's land. Sir Arthur Conan Doyle was the first president. In 1946, the professional, Dai Rees, set a new course record at St Andrews when he went round in 67 in the first round of the Open Championship. A month later, Rees, who had come to Hindhead before the war, succeeded the legendary Harry Vardon as the professional at the South Herts club. The natural undulations make Hindhead a sporting course, and one writer observed that it was a 'perfectly ideal setting for the Royal and Ancient game'.

HASLEMERE HALL was a very generous gift from Mr Barclay Day of Dene End to the people of the town although he did not live to see his project completed. The hall was finished in January 1914 but, soon after, war broke out and it became a club for soldiers from the several large camps in the district. The entrance was altered later and an annex added on the eastside in the 1960s.

PANTOMIME was born in Haslemere in 1899 when a Christmas play, *Aladdin*, was performed at the rectory under the guidance of the Revd Aitken. Pantomimes then became a regular feature from 1901 in the hall at Haslemere School, Chestnut Avenue, and later in Haslemere Hall. It was here, in 1914, that *Alice in Wonderland* starred Joan Oldaker in the title role with Mr Gaskin as the turtle and Dr Jenner as the griffin, their wonderful costumes being designed and made by Miss Geike and Miss Fynes-Clinton.

Festival of CHAMBER MUSIC

August 20th to September 1st, 1928.

HASLEMERE HALL.

Tickets —
CHARMAN'S,
HIGH STREET,
HASLEMERE, SURREY,
ENGLAND.

Photo by Carbonora, Liverpool

ARNOLD DOLMETSCH PLAYING THE ARCHLUTE.

ARNOLD DOLMETSCH brought his family to live in Haslemere just before Christmas 1917. They had lived in France prior to the First World War but when they came to England had stayed for a time at Thursley before moving to Jesses. They first became acquainted with the area while staying with George Bernard Shaw at Hindhead. The now world famous Haslemere Festival of Chamber Music began in 1925. It continued with an unbroken series of concerts at Haslemere Hall under the leadership of Arnold until 1939 and then his son Carl until his death in 1997. Since then, annual concerts of chamber music have been held at Haslemere Education Museum until 2008.

FESTIVAL of CHAMBER MUSIC

Aug 24th–31st. 1926.

HASLEMERE HALL

Tickets: Charman's High St. Haslemere SURREY. ENGLAND

MEMBERS OF THE DOLMETSCH FAMILY appearing at the Haslemere Festival in 1926 were, left to right: Mabel, Nathalie, Arnold, Carl, Cecile, and Rudolph.

THE RAMSNET CUP was given by Sir Harry Waechter of Ramsters near Chiddingfold to be competed for by bands from within an eight-mile radius of his home. Haslemere Town Band won the cup at the first competition in 1907. The winning players included, in the back row: Percy A. Bridger (secretary), first left and Mr Weekes, fourth from left. In the front row: Ernest Bridger, third from the left and York Bridger, in centre behind the cup. G. Goodchild was the conductor. During the next two years the cup was won by the Institute Band, formed when the Workmen's Institute was given to the town in 1886 by Stewart Hodgson. After the First World War Turner Bridger found there were too few bandsmen surviving for two bands to continue and so the Institute and Town bands were amalgamated under his presidency. After his death in 1928 the lord of the manor, Sir Richard Garton, became president until he died in 1934. Since the Second World War the presidency has returned to the Bridger Family, first in 1961 with Mrs D. Masters, granddaughter of Charles, and currently with her grandson Tony Waddell.

HASLEMERE TOWN BAND had its origins in 1834 when a small band was started by Charles Bridger (right) and his brother William. At about the same time the second band was formed by two other brothers, Edward and William Berry. The two bands amalgamated in 1838 to play at the Queen Victoria Coronation celebrations. During the latter part of the nineteenth century the band included nine Bridgers, William together with his seven sons and their cousin Turner, and for a time became known as the 'Bridger Band'.

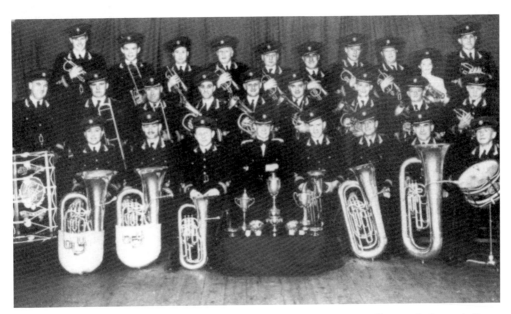

HASLEMERE TOWN BAND 1951. Back row, left to right: R. Farrant, D. Clement, L. Berry, A. Berry, F. Berry, G. Dobson, E. Bicknell, J. Dudman, M. Brooker, F. Howkins. Middle row: G. Scowan, R. Mullins, G. Mellham, E. Venton, A. White, J. Lunn, E. G. Brooker, E. W. Brooker, D. Stacey. Front row: W. Martin, A. Alcock, B. Roe, J. B. Thomas (bandmaster), E. Cardy, C. Davis, P. Hedges, B. Thomas.

TOBIAS MATTHEY was perhaps the foremost teacher of piano playing some sixty years ago. He and his· wife made their home at High Marley on Marley Heights where they became well known to local people who remember them with affection. Among Tobias's pupils were Ernest Lush and Eileen Joyce who was later to give a celebrity concert at the Rex Cinema. His sister Dora was married to a member of the another musical family, the Kennedys, the eldest of whom wrote the *Hebridean Songs* that were so popular on the radio during the 1930s.

RON REYNOLDS (right), pictured with a great Shottermill character, Charlie 'Devvy' Rapson, was a boyhood hero to many a local lad interested in football during the 1950s and early 1960s. He was a goalkeeper who caught the eye of Football League club scouts and progressed from Aldershot in Division Three (South) to Tottenham Hotspur in the First Division. Reynolds, who also kept wicket for Shottermill during the summer, had his soccer career ended prematurely by injury shortly after a transfer from White Hart Lane to Southampton.

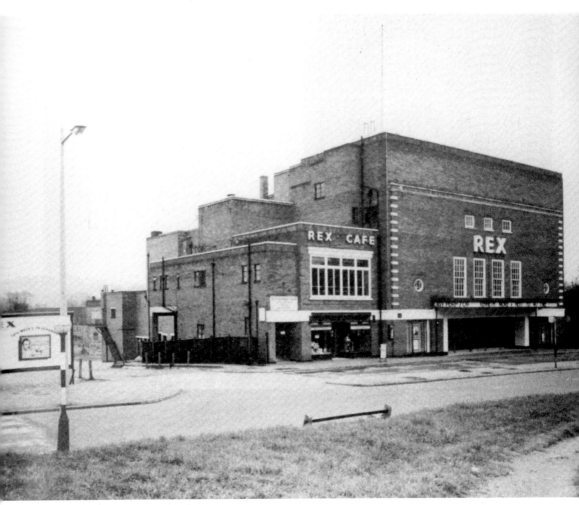

THE REX was built by Chapman, Lowry and Puttick for the Haslemere Cinema Company and opened in 1936 under the management of Mr Tomkins who lived at Weysprings House. During the 1950s, in the days before the video, there were changes of programme on Monday and Thursday with matinées on Wednesday and Saturday. A different programme was shown on Sunday evenings, much to the disgust of James Ayling who stood across the road with his protest placard whenever performances took place. In 1953 Richard Killinger came to Haslemere fresh from organising the post-war cinema for J. Arthur Rank in Germany and Spain. He was able to ensure that feature films were seen much sooner after release from London than had been possible before. He also organised a series of celebrity concerts with classical music stars including Eileen Joyce, Myra Hess, Moiseivitsch, Ashkenazy, and even Sir Adrian Boult with the London Philharmonic Orchestra. Popular music and jazz concerts in the 1960s included Acker Bilk, Bert Weedon, the Wurzels and the Clyde Valley Stompers. During the Dolmetsch Festival the Rex, with its much greater seating capacity than Haslemere Hall, was used to stage special concerts for the local school children. What a sad day for Haslemere when the Rex was demolished in 1986 to be replaced with a block of flats hardly in keeping with that part of the town.

EDWARD BLAKEWAY I'ANSON was the donor of a silver cup for cricket in 1901, and his name has been synonymous with the game locally ever since. The original trophy, won outright by Tilford in 1910, was replaced the following year by Mr I'Anson, a London architect whose family home was in Grayshott, on the understanding that it would never again become the property of an individual club.

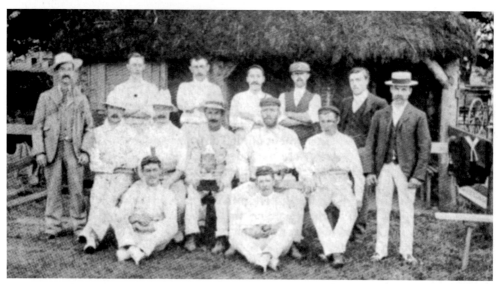

LYNCHMERE competed for the I'Anson Cup in the first ten years of the competition, winning the trophy in the first two years and very nearly outright in 1903 when Grayshott, whose top scorer was Sir Arthur Conan Doyle, beat them in the final game. Walter Harding, captain throughout those ten years, holds the cup in 1902. He was the bailiff at Lynchmere House, behind which the club plays. His brothers, Arthur and William, are seated to his right. Others pictured are, back row, left to right: J. Adams, P. Pheasant, G. Madgwick, D. Payne, G. Madgwick, A. W. Smith, W. Merridan. Seated: E. Moorey, P. Madgwick. On ground: G. Puttick, A. West.

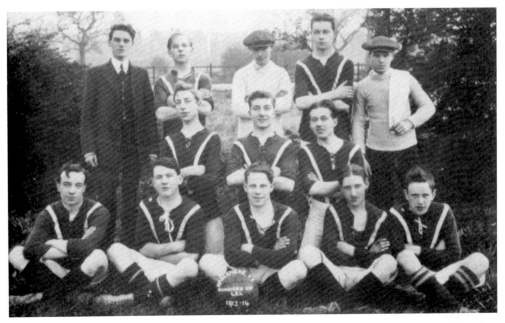

HASLEMERE FOOTBALL CLUB in 1913-14, the last season before the Great War put a stop to organised sport for five years. The club has appeared in four different guises since its formation: as Haslemere and Shottermill United, then Haslemere Athletic, followed by Haslemere FC, following a merger with Grayswood FC, and currently as Shottermill and Haslemere FC.

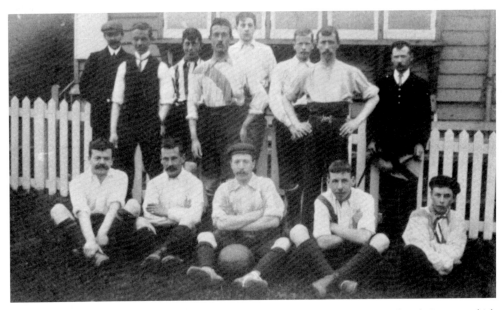

HASLEMERE POST OFFICE FOOTBALL CLUB competed in the Surrey Midweek League which offered a regular fixture list for those plays whose Saturday occupation often prevented them from taking part in sport at the weekend on a regular basis.

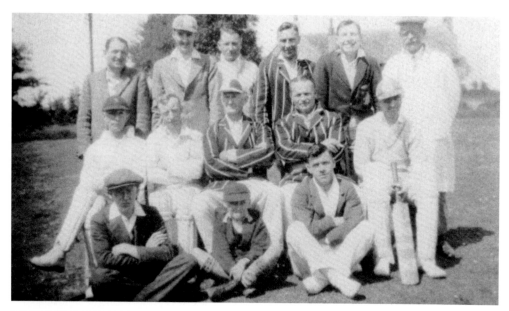

HASLEMERE CRICKET CLUB was founded in 1827 and has played its home matches on the Recreation Ground since 1921 when the ground was given to the town as a First World War memorial. Previously the club had played where the hospital now stands, and before that from the time of its inception at Lythe Hill House. This picture shows a club team during a Whitsun match at Pagham in 1931.

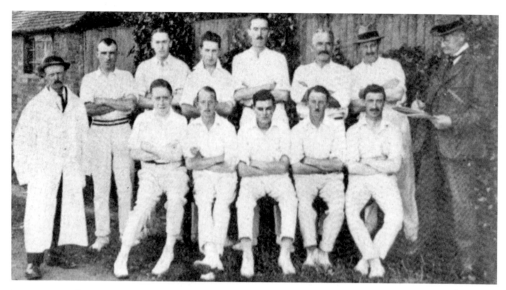

THURSLEY first entered the I'Anson Cup competition in 1921, and won the trophy three years later, but apart from a purple patch in 1970-2 when they completed a hat-trick of titles, success has otherwise eluded the first XI. There have always been Rapleys connected with the club, whose recent secretaries have been Barry and Linda Rapley. The 1924 picture shows, standing, left to right: C. Wisdom, F. Howard, H. Rushbrooke, C. Wisdom junior, J. Rushbrooke, G. Warner, F. Rapley, H. S. Tozer. Seated: R. McCullough, M. L. Rapley (captain), T. Wisdom, V. C. Rapley, H. Swallow.

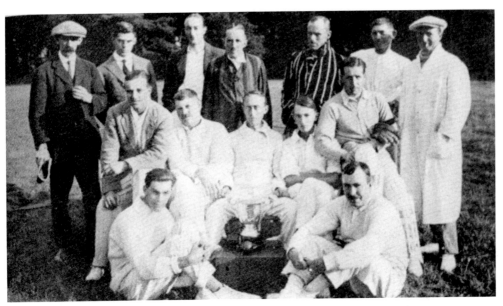

CHURT were founder members of the l'Anson Cup competition, and first won the league in 1911 when they played their home matches on a ground off Pond Lane between the A287 and Frensham Pond Hotel. The club moved to the Recreation Ground in the village, where this 1922 picture was taken, when it was donated as a First World War memorial. Standing, left to right: W. Voller (scorer), A. Harris, R. F. Bremner, H. B. Davie, E. H. Ashby, B. Silvester, K. West (umpire). Middle row: L. Gardiner Hill, A. Carver, A. R. T. Baker (captain), B. Wonham, F. D. Berridge. On ground: W. Martin, W. Checkley.

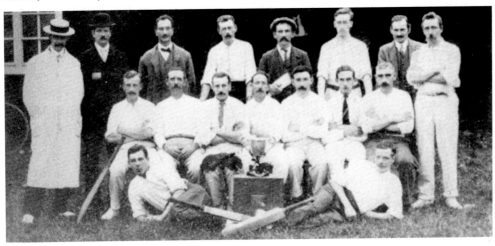

SHOTTERMILL played cricket at Lion Green in the days when they were a force in the l'Anson Cup, and 'Dukey' Moorey is said to have scored 99 off one hit when the ball lodged between two chimney pots, remained visible and could not be declared 'lost', those being the days before boundary lines. The 1913 photograph shows, standing, left to right: B. Rapley, G. Woodward, E. G. Ford, C. Rapson, E. Dicker, R. C. Brown, A. F. Riddle, T. J. Larbey. Middle row: W. Pullinger, E. Moorey, W. Balchin, G. Knottley (captain), N. Smithers, W. Dale, C. Pescod. On ground: H. Tickner, P. Booker.

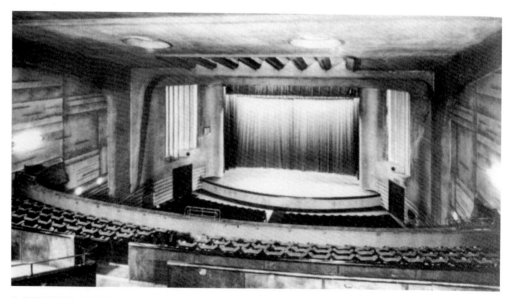

A FAMILIAR SIGHT to movie buffs was the auditorium of the Rex Cinema. Look carefully at the moulded arch in front of the stage. This is asymmetrical, the result of damage caused when the engine from an aeroplane that crashed between the Holy Cross Hospital and the cinema on 22 September 1942 broke through the wall and the stage into the basement below. The crew of three were killed but fortunately the Tuesday matinée audience was sparse and the most serious injury sustained was a broken leg.

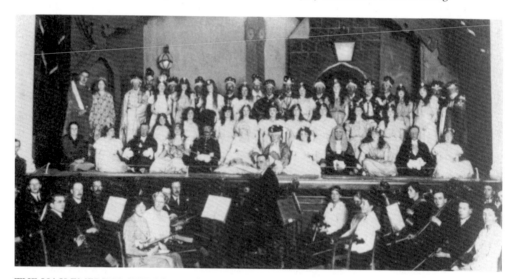

THE HASLEMERE PLAYERS began their long and successful run of Gilbert and Sullivan operettas in 1905 with a performance of the *Mikado* in the school hall at Chestnut Avenue. *Iolanthe* was the 1919 production at Haslemere Hall. The principals in the cast were front row, seated, left to right: -?-, Mrs Austen? (Celia), Lewis Bailley? (Tolloller), Miss Ruth Ardagh (Fairy Queen), Mr A. L. Gaskin (Private Willis), Mrs E. St G. Kirke (Phyllis), Mr George Whitfield (Stretton), Miss Frances McKeen (Iolanthe), Mr W. E. A. Austen (Lord Chancellor), Miss K. Chandler (Leila), Mr C. W. Jenner? (Mount Ararat), Miss Audrey Stables (Fleta). The orchestra was conducted by Mr W. E. Muir.

SECTION SIX

Churt and Thursley

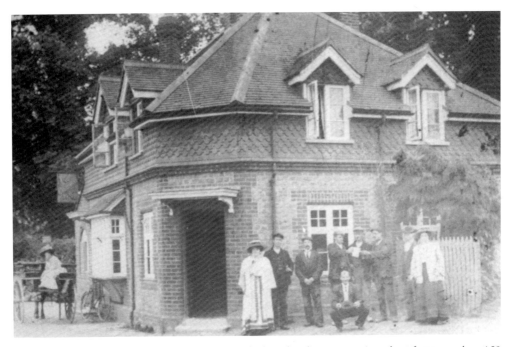

THE CROSSWAYS public house in the centre of Churt has been a meeting place for more than 150 years. This photograph was taken around 1905 soon after the inn had been rebuilt following its sale to Farnham United Breweries by Trimmers. For a time it was known as The Shant, supposedly because of the landlady's put-down to amorous customers. Whether that lady was a member of the family of Arthur Chuter, bricklayer and publican, listed in the 1881 census as living at The Shant is unknown.

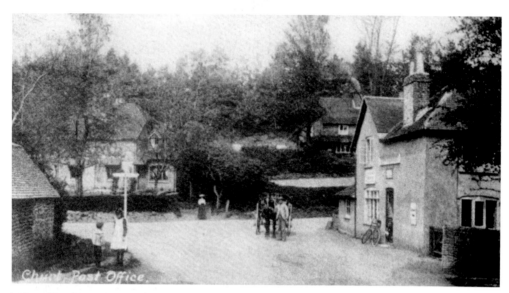

THE OLD POST OFFICE at Churt and Wayside Cottages on the junction of the A287 and Jumps Road were a long way from the centre of the village. The Star public house, at the foot of Star Hill, was opposite the post office, and both are now private houses. This was an area beloved of Bryan Hook, the Royal Academician, who lived at Silverbeck in Jumps Road, so called because of the Devil's Jumps, three hills rising out of the heather. Stony Jump is owned by the National Trust, Middle Jump and High Jump, which has a house on the top, are private property.

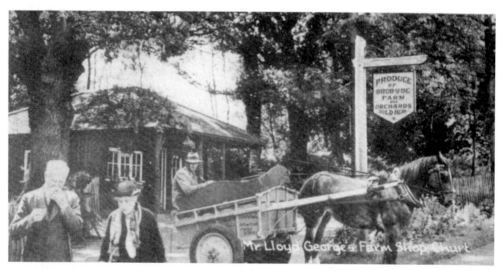

THE FORMER PRIME MINISTER, Mr David Lloyd George, farmed in a big way between the Devil's Jumps at Churt and Hindhead, and sold much of his produce at his shop opposite the Pride of the Valley Inn. After Lloyd George's death, the shop was eventually converted to a restaurant called the Devil's Grill, where the proprietors, Mr and Mrs Norris Jones, held a party for people with the surname Jones on the eve of Princess Margaret's wedding to Antony Armstrong Jones in May 1960. A plan to turn it into a private club, which had the backing of top showbusiness personalities, failed, and the property is now a private house.

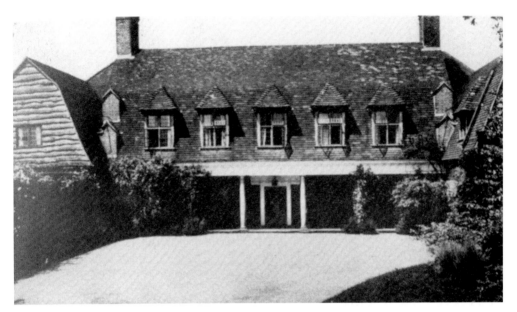

MR LLOYD GEORGE built Bron-y-de close to the Pride of the Valley Inn when he moved to the area in 1921. He bought hundreds of acres of rough land from Lord Ashcombe, set pigs to work, and in no time was a prominent market-gardener and fruit-grower with an irrigation system using water pumped from a borehole off Old Barn Lane. Bron-y-de was destroyed by fire in the 1960s, and Churt Place was built in its place.

A DELIGHTFUL SHOT of David Lloyd George and his politician daughter Megan in 1935. After the death of his first wife, Lloyd George married his long-time secretary Miss Frances Stevenson, who continued to live in Churt, with her sister, long after Lloyd George's death. Lloyd George's home for twenty-four years was close to the Pride of the Valley Inn which was so-called when it was built in 1870 and not renamed, as so many would believe, when the Welsh political giant came to the area.

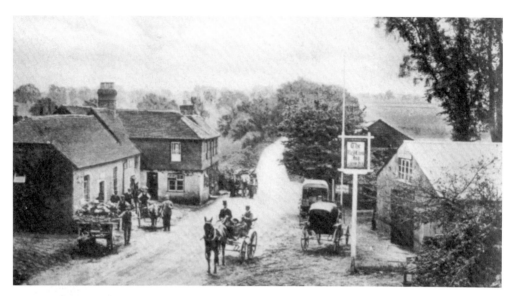

OLD DOCUMENTS refer to the Red Lion as being in Road Lane, an early name for that part of the Portsmouth Road at Thursley. It was here that the 'unknown sailor', murdered on Hindhead in 1786, drank with his killers, and to where the executed criminals were returned so that Richard Court, the Thursley blacksmith, could make alterations to the chains in which the three were hanged on Gibbet Hill. It was said that the crowd there was so great that young Mary Tilman from Frensham was pushed forward and trod on the head of one of the villains. The Red Lion ceased trading about fifty years ago and is now a private house.

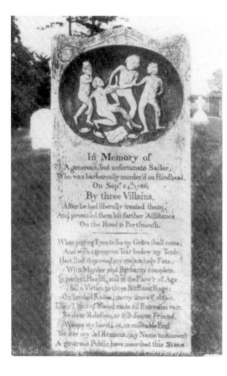

THURSLEY'S PARISH CHURCH of St Michael's and All Angels is tucked away in a picturesque village, and visitors to the churchyard usually make for the north side where they quickly find the gravestone to the 'unknown sailor' murdered on Hindhead in 1786. The crime took place in Thursley parish and the people of the village clubbed together to give the man a proper burial and a lasting memorial. Henry Smithers was paid 7s. 6d. to make 'a cofen for the man that was fd ded uppon Hindhead'. Near the gate to the church is the grave of Richard Court, the blacksmith who made the chains which held the three murderers on the gibbet.

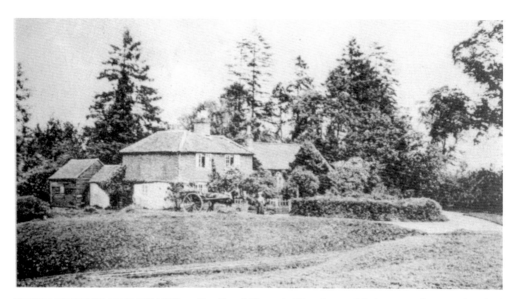

THERE HAS BEEN NO CHAPEL at Bowlhead Green in Thursley parish for more than one hundred years, since the death of the last minister, Mr Isaac Kettle, in 1906. Kettle was a roving preacher who ministered to the families living in the Devil's Punch Bowl for twenty-five years until age caught up with him and he was forced to retire in 1890. His annual tea parties at different homes in the Bowl were events not to be missed and attracted people from many miles around. When the preacher died, the chapel at isolated Bowlhead Green was bequeathed to a relative and became a cottage.

IN THE EARLY PART OF THE LAST CENTURY even the smallest hamlet had a post office as can be seen in this 1923 view at Bowlers Green, now more usually known as Bowlhead Green. The postmistress at the beginning of the twentieth century was Miss Denyer but it seems her job disappeared later as this post office was not listed in the 1929 edition of the Post Office Guide.

THE VILLAGE HALL at Thursley is now at the old school opposite the Three Horseshoes, but for many years it was situated to the east of the pub. There is a private house where the hall once stood, but otherwise the view is very much unchanged.

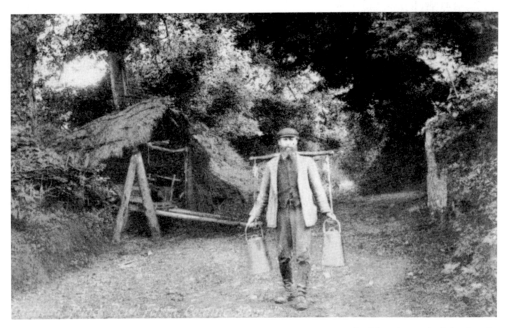

GEORGE MAYES, who died in 1939, was born in Keeper's Cottage at the Thursley end of the Devil's Punch Bowl and, apart from seven weeks in Haslemere Hospital, never moved away. His home for the last forty-six years of his life was Highcombe Farm in another part of the Bowl, where, after the death of his mother, he lived alone for thirty years without electricity or radio, and with only a brass gong and stick to raise the alarm in an emergency. He farmed until the First World War and was also Hindhead's milkman, travelling on foot with heavy pails suspended from a yoke.

SECTION SEVEN

Events

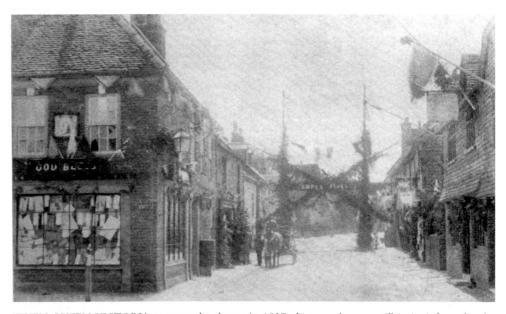

WHEN QUEEN VICTORIA came to the throne in 1837 photography was still in its infancy but by the time Haslemere came to celebrate the Golden Jubilee on 21 June 1887 architect and surveyor John Wornham Penfold had acquired a camera and was able to record the local festivities. This view of Petworth Road shows the bunting and flags that were used to decorate the shops and houses. On the left, draper Walter Fogden vied with Mark Bicknell across the road at the White Lion as to who put on the best display. Further along, William Charman, a stationer who also ran the post office, grocers William Deas and George Falk, together with local residents including Charles Bridger and his son Turner were all probably involved in constructing the arch of wooden scaffold poles and foliage across the road. The Jubilee celebrations began with a Service of Thanksgiving at St Bartholomew's followed by a public dinner held at several different venues in the town since no one place was large enough to seat the 523 people who attended. Six places were used including the Club Room and Assembly Room behind the White Horse, the Infants School room and library in the Town Hall and the very new Working Men's Club room at the Institute built for the town by Stewart Hodgson only the year before. After the meal had settled a great effort was required to entertain 324 children at tea parties in the same rooms. In the evening many of the inhabitants journeyed up to Gibbet Hill where a large beacon was lit at 8.30 p.m., a tradition continued to this day in celebration of royal events.

THIS POSTCARD VIEW sent on 15 May 1907 has the message 'The excitement here is a new fire engine which was given to the town on 1 May.' The new steam fire pump is shown being pulled round Penfold's Corner on the journey from Haslemere station to the High Street where the presentation took place. At the front of the procession members of the Haslemere Band wearing sashes are followed by the Institute Band.

ON MAY DAY 1907 Mr (later Sir Richard) Garton presented Haslemere with a new steamer for pumping water on to fires. Accepting his generous gift are the Brigade Captain who was the Earl of Altamont (bareheaded) and 2nd Officer John Henry Howard who, together with eighteen volunteers, made up Haslemere Fire Brigade to its full strength. Mr Garton (on the left) had recently moved to the town and bought Lythe Hill from Stewart Hodgson. The Earl of Altamont was married to Mr Hodgson's daughter Agatha and soon succeeded his father as 6th Marquis of Sligo.

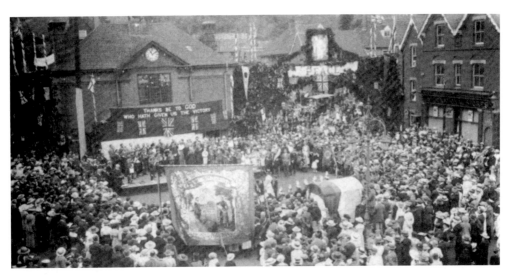

PEACE DAY. 19 July 1919 when almost everybody in the town gathered in the High Street to celebrate. The Urban District Council led by chairman James Edgeler, a harness-maker born in 1848, were joined on stage by boy scouts to sing as the Town Band played. To the right of the banner of the Ancient Order of Foresters the firemen's helmets are just visible over the electricity sub-station that has been draped with flags.

HOUSES opposite the Georgian Hotel decorated to celebrate Peace Day. The eighteenth century double-fronted house with four white steps had been home for Dr Henry Whiting, medical officer and public vaccinator for the districts of Hambledon, Haslemere and Shottermill until the 1890s when he was succeeded by Dr Winstanley. In around 1930 the ground floor of this house was converted into two shops. The rather low cottages next door were demolished to make way for the Haslemere Motor Company Garage, more recently showrooms of the Concours Motor Company and now an interior design shop.

HASLEMERE HOSPITAL required enlarging from the moment it opened in 1923. The carnivals held during the twenties and thirties provided a good opportunity for fund raising and soon the necessary money was collected to build a ward for children.

A CARNIVAL was held in Halsemere every year in the 1920s and 1930s. The carnival queen in 1936 was Mrs Lily Marchant who is seen here surrounded by her maids of honour. From left to right: Miss Ivy Downe, Miss Mollie Agar, Miss N. Lockley and Miss D. Lockley.

SECTION EIGHT

Bramshott Chase and Camp

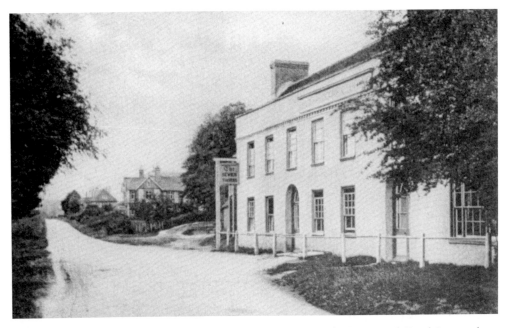

THE SEVEN THORNS dates from 1500 and owes its existence to the Portsmouth Road. It was a busy hostelry long before the motorcar ruled. The coach and horses, and their passengers, found the inn a welcoming sight as they crossed the barren landscape between Hindhead and Liphook. It later became a haunt for the soldiers camped at Bramshott, and was a favourite stopping-off place for day-trippers from London who roamed the commons at the weekend. Since then it has been named The Spaniard, a far cry from the pub that took its name from seven ancient trees on the opposite side of the old road. The Spaniard is now empty and a delapidated ruin.

THERE WAS A POST OFFICE in Bramshott Chase at least from 1911 (see below) to the 1960s when this site was closed. This office opened around 1924 and was run by people called Madgwick. Next door was a garage owned by a family of the same name, which is well known in the Haslemere area.

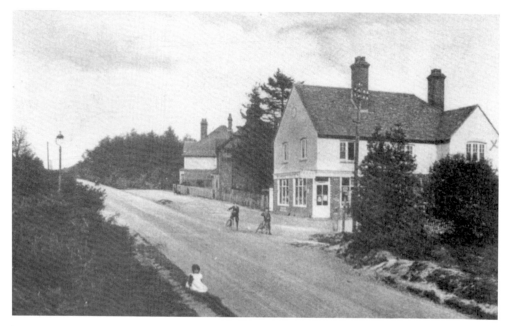

THIS BUILDING on the corner of Hammer Lane and the A3 dates from 1911 when it was a post office run by Miss Mary Amelia Abbott. But it is best remembered as the Blue Jug Tea Rooms, whose long-time proprietor was Miss Florence Bumstead. Her main trade came from Londoners out for the day who liked to return home with souvenirs, including a little blue jug. A new dual carriageway being built here in 2009 will lead to the tunnel under Gibbet Hill, which is due to open in 2011.

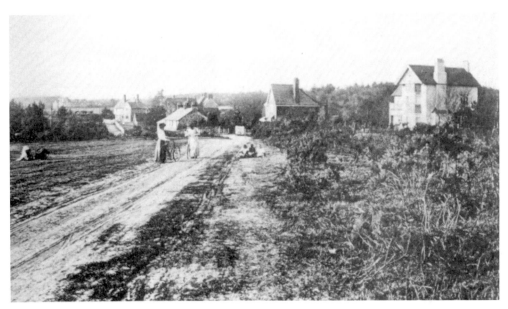

AN UNUSUAL VIEW at Bramshott Chase looking north-east from Hamphire into Surrey. The area is known locally as Ravens Vale, hence the existing Ravens Vale Cottages in Hammer Lane off the A3. At the nearby Spaniard Inn, a nightclub was called Ravens but there is no indication that there is a connection between the two names.

A LATE 1920s ADVERTISEMENT for the Seven Thorns Hotel (see p.99) which then enjoyed a boom period as people motored out into the country to explore the wild heathland around Hindhead and Liphook. Bramshott Chase was an ideal centre, and the beautiful ponds and woodland at Waggoners Wells were a short walk to the north.

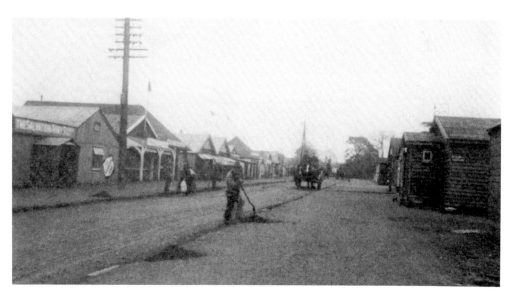

DURING THE FIRST WORLD WAR a large army camp was constructed south of the A3 between the Seven Thorns and the Blue Jug. The Canadian Army Service Corps arrived here in October 1915 followed shortly afterwards by the first of many infantry battalions. 'Tin Town' was a group of corrugated iron huts that sprang up alongside the main road westwards from the Seven Thorns, just visible in the background. They were run as shops by local tradesmen who supplied the everyday needs of the soldiers.

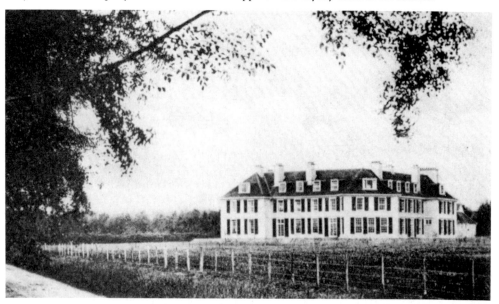

THE HOSTEL AT BRAMSHOTT CHASE was founded in 1907 by a Hindhead woman of considerable wealth, Miss Marian Julia James, of West Down, Portsmouth Road, whose name is remembered by a stretch of National Trust land near her old home. The intention of Miss James in building the Hostel was to enable 'educated men and women' to have a 'timely holiday' in the country and so stave off any threat of 'over-strain and resulting illness'. Subsequently it became Mount Alvernia Nursing Home and is now Shannon Court Care Home.

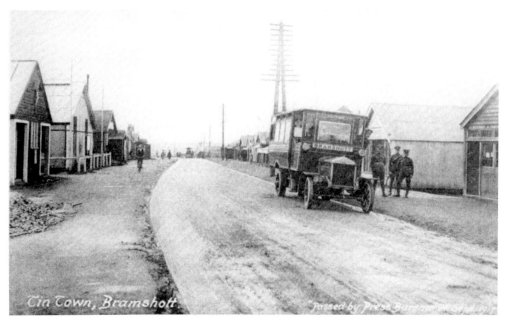

THE VIEW west through Tin Town towards Liphook in 1917 along what is now the A3 dual carriageway. Aldershot & District buses ran from the company's office in Tin Town to Hindhead and then on to Godalming via another large Canadian army camp at Witley.

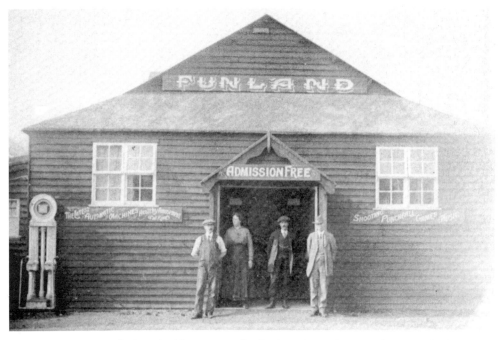

A POPULAR HAUNT for bored soldiers was Funland in Tin Town. This was a large wooden hut on the north side of the road where the entertainments included billiards, slot machines and even a miniature rifle range with a prize of 2 *s.* 6 *d.* for the best score.

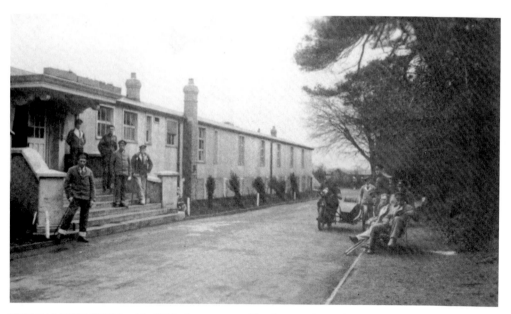

THE CAMP HOSPITAL with 630 beds was opened by the British in November 1915. It was taken over by Canadian staff in September 1916 and became No. 12 Canadian General Hospital.

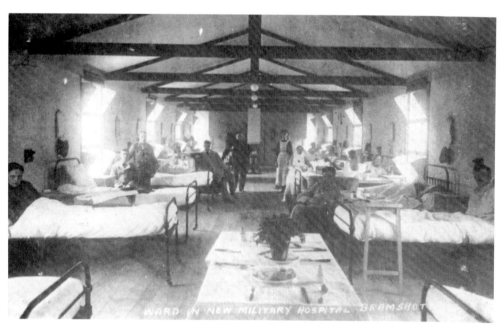

THE HOSPITAL WARDS were in wooden huts but as much comfort as possible was provided for both battle casualties and also Canadian soldiers suffering from ailments due to living in a foreign land with its different bugs and climate. Towards the end of the war influenza caused more deaths in 1918 and 1919 than had other illnesses or even wounds during the earlier years of the conflict.

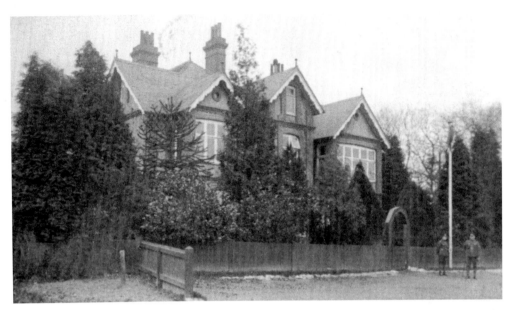

DRIVERS AND FAMILY GROUPS will know this building as the roadside café on the A3 just over the Surrey-Hampshire border. It started out as an Edwardian mansion with thirteen bedrooms and three reception rooms set in two acres, an ideal property to be let to the War Office as a divisional headquarters for Bramshott Camp. With hostilities over, it was let to a Miss Roberts as a children's home and ten years later, in 1931, it became known as Gorselands Hotel when it was let to a Mr Harris.

GORSELANDS PRIVATE HOTEL, which is shown in the top picture when it was the divisional headquarters for the camp at Bramshott, was built around 1907. After the War Office had departed, it became a children's home and then an hotel.

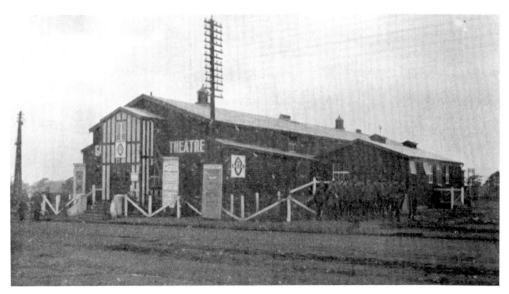

THE GARRISON THEATRE at Bramshott Camp also doubled as a cinema. This photograph was taken in November 1917 when the Navy and Army Canteen Board Players were performing *The Magistrate* twice every evening at 6.15 and 8.30. The theatre was operated by the NACB (similar to the present day NAAFl) and reserved seats cost 2 *s.* and 1 *s.* while unreserved entrance was 6 *d.* or 3 *d.* Prices for the cinema were similar but the most expensive seats were only 1 *s.* The shows were enjoyed by local people as well as the soldiers from the camp.

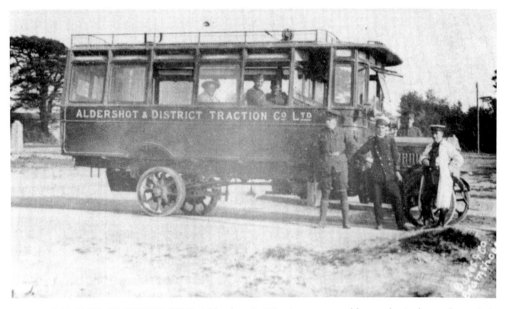

DURING THE FIRST WORLD WAR Aldershot & District were unable to obtain buses from their usual suppliers, Daimler and Leyland, to cope with the extra demands on public transport brought about by the large numbers of troops based in the area. A number of Belsize goods chassis were fitted with various bus bodies, including this one photographed at Bramshott Camp.

SECTION NINE

Over the Border

LOOKING TOWARDS HASLEMERE from the little hamlet of Kingley Green around 1905. Formerly known as Kingsley Marsh it is part of the parish of Fernhurst, but located midway between there and Haslemere. The main road was part of the turnpike from Milford to Midhurst and was closed by a gate at the Tolle House just up the hill from the point where this picture was taken. The buildings on the left of the road were demolished some fifty years ago to straighten what was a dangerous bend for motorcars to negotiate.

JUST ALONG FROM THE TOLLE HOUSE at Kingsley Green was the general stores, bakery and post office that belonged to Ebenezer Mills. Later his two sons ran the business; Jack baked the bread and also worked the farm while Harold was in charge of the shop. The shop was closed in 1968. The road was later re-aligned so that today these buildings do not have vehicles passing close to their front doors.

MOSES HILL FARM stands high above West Sussex near the end of Marley Heights. This photograph was taken around 1910 when the farm was home for one of Sir Jonathan Hutchinson's ten children, Herbert, who lived there with his wife Elizabeth and their family until 1913 when they moved down to a larger house in Kingsley Green. After Sir Jonathan died the estate on Marley of around 265 acres including Moses Hill was sold by auction In 1914.

The Frescoes, Shulbrede Priory.

SHULBREDE PRIORY, nestling in the valley south of Lynchmere, was founded around 1190 by Augustinian Canons. The priory suffered the fate of many religious houses in the sixteenth century when it was dissolved by Henry VIII. Only a small part of the original priory has survived into the present century but this includes the important frescoes, dating from around the time of the dissolution, painted on the walls of the Prior's Chamber.

ARTHUR PONSONBY came to live at Shulbrede Priory in 1902. He bought the house from the Cowdray Estate in 1905, the same year that he was elected as a Liberal Member of Parliament. Later he moved to the Labour benches and, soon after becoming a peer in 1930, Lord Ponsonby was leader of the opposition in the House of Lords from 1931-5. Together with his wife Dorothea, daughter of the composer Sir Hubert Parry, and assisted by his children, he wrote the definitive history, *The Priory and Manor of Lynchmere and Shulbrede*, published in 1920.

ST PETER'S CHURCH stands on the crest of the hill at Lynchmere with a fine view to the south. Built more than nine hundred years ago the church has an infamous connection with Haslemere in that James Fielding, the highwayman rector, was curate here from 1777–1801. Mailbags stolen from the London to Portsmouth coach were found after his death in one of his homes, Town House, in Haslemere High Street. He is also believed to have employed the Drewett brothers who robbed the mails at North Heath, Midhurst in 1799, a crime for which they were hanged.

LOOKING DOWN HEATH ROAD, Hammer in 1924. Many houses were built here and in Copse Road to provide homes for John Grover's employees after he expanded the brickworks around 1900.

THE WEALDEN IRON INDUSTRY thrived from the sixteenth to the eighteenth century. Hammer derived its name from the iron forge once situated at Pophole, or Pophall, the point where three counties meet in Hammer Vale. When this pretty spot was part of industrial England just over two hundred years ago the 'Kissing Bridge' was the sluice controlling the flow of water from a pond that provided the source of power for the iron hammer. Both Pophole and the furnace at Northpark ironworks were partly or wholly in the parish of Lynchmere and owned by Lord Montague of Cowdray. Another iron hammer was at Sicklemill and a furnace at Imbhams, Grayswood – industrial England before the discovery of coke.

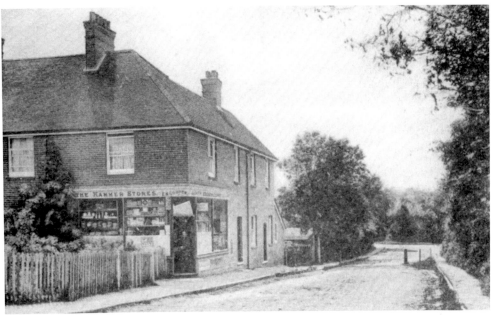

HAMMER POST OFFICE AND STORES in 1924 with the proprietor Mr E. Cooper standing in the doorway. This shop was on the corner of Heath and Copse Roads until it closed and became a private house called 'Grovers' after the bricks exposed during alterations to the building.

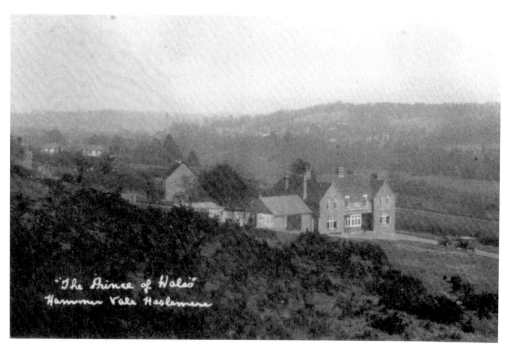

WITH THE INFLUX OF BRICKMAKERS and others into the Hammer at the beginning of this century the need for a new public was fulfilled in 1927 when the Prince of Wales was built in Hammer Vale. The brickworks chimney in the background was a local landmark until demolished around 1940, an event vividly remembered by Andy White and a school friend who were surprised by the charges exploding as they walked along the lane through Hammer.

HOW TRANQUIL was the scene at Camelsdale in 1917 before the Midhurst Road became filled with motor vehicles.

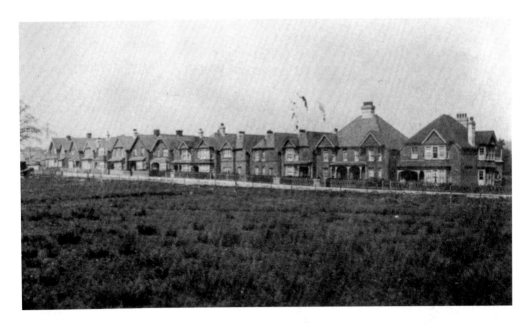

THIS VIEW OF STURT AVENUE was sent as a postcard in February 1912 by a lady called Margaret who was moving during the next week along the road to Mydleton, the house marked with an X at the extreme left. Camelsdale, like Hammer, grew quickly during the early years of this century and many of the houses were built by the Silk Brothers using local Grover bricks. Some of these houses provided homes for the men employed at Hammer Brick Works, the same workers who had produced the bricks with which they were built.

THE CLEAR WATERS arising on Blackdown used to cross over the road in Camelsdale at a ford, very useful to the drivers of wooden carts as it gave them the chance to swell dry spokes and felloes and tighten up rattling wheels. Just behind the cottages a leat, a man-made channel, begins its journey along the hillside. It once carried water to Sicklemill to help power the water-mill.

AN EARLY VENDING MACHINE is prominent in this 1930s picture of Bell Road taken outside the general stores run by Harold Roe who looked after his customers' needs from a wheelchair. The shop closed in the early 1950s, was later a restaurant and is now a private house. The main A286 road was straightened in the 1960s and no longer passes close to the cottage gates.

THE NARROW AND DUSTY COUNTRY LANE in 1905 is now the A287. The houses Sturt Road, quite newly built when the photograph was taken, are little changed today. But the large beech tree is now gone and the bank opposite has been cut back and flattened, both improving visibility and providing space for cars to park near the houses.

SECTION TEN

At Your Service

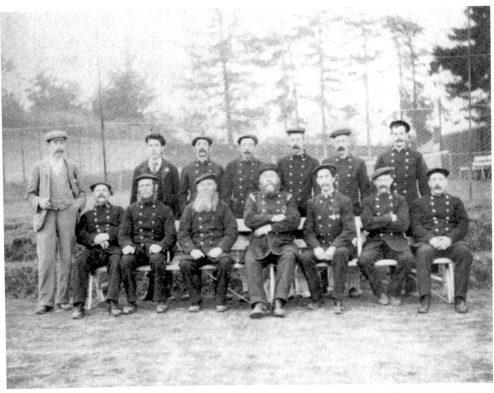

A VICTORIAN GROUP OF THE HASLEMERE FIREMEN. The Haslemere Volunteer Fire Brigade was founded in 1878 under the leadership of James Simmons who was captain; a draper from the High Street, J. R. Bridger, was superintendent, and William Maides, the blacksmith from Lower Street, was the first engineer. In those days before the use of bells or sirens Turner Bridger as the brigade bugler, perhaps using the same instrument to warn townsfolk that a fire was burning as he played in the Haslemere Band.

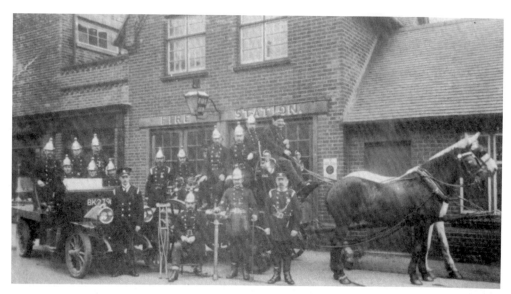

THE FIRE STATION in West Street was built around 1906 after the road was constructed to give access to the new school (see p. 41). This group photographed around 1920 includes Fireman Lewis who lost one leg during the First World War but was retained to run the fire station as he lived just round the corner in Popes Mead. The horses belonged to corn merchant Henry Purkis and were stabled behind the Red Lion in the High Street.

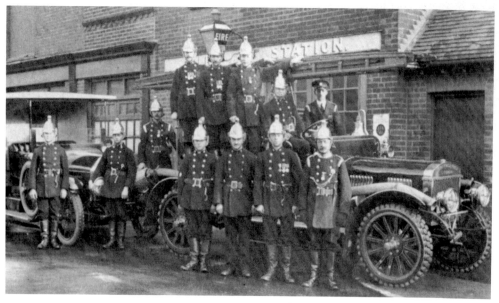

IN 1934 SIR RICHARD GARTON gave Haslemere another fire engine, this time a Merryweather machine, so the horses of Henry Purkis were no longer needed. The driver of the fire engine was Mr Strudwick and the fireman on the left was George Mills from the grocery shop at Junction Place (see p. 96).

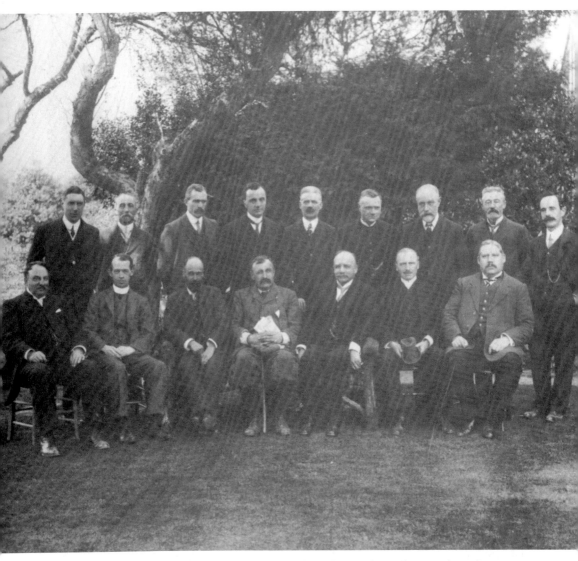

THE FIRST PARISH COUNCIL in Haslemere was formed in 1894 with Sir Robert Hunter as chairman. Under his leadership lighting, roads, footpaths, sanitation and many more improvements were made – and all for a rate of only ½ *d*. in the pound. In 1913 the Parish Council was granted a new status and became the first Urban District Council of Haslemere. The members of this first council were, back row, left to right: Mr H. V. Snook (surveyor), Mr A. Bicknell, Mr C. J. Welland, Dr R. J. Hutchinson (medical officer of health), Mr J. G. Madgwick, Mr W. Heather, Mr J. H. Meadows, Mr T. H. Barkshire (collector), Mr A. G. Whitcher (clerk) – he also took the minutes of the first Parish Council meeting. Front row: Mr T. Bridger, Revd J. S. Leake (All Saints', Grayswood), Mr E. Ely (vice chairman), Allen Chandler Esq, JP, CA (chairman), Mr S. Smallpiece, Revd G. H. Aitken (St Bartholomew's) and Mr W. C. Waterston. Both Allen Chandler and Turner Bridger had also been members of the first Parish Council.

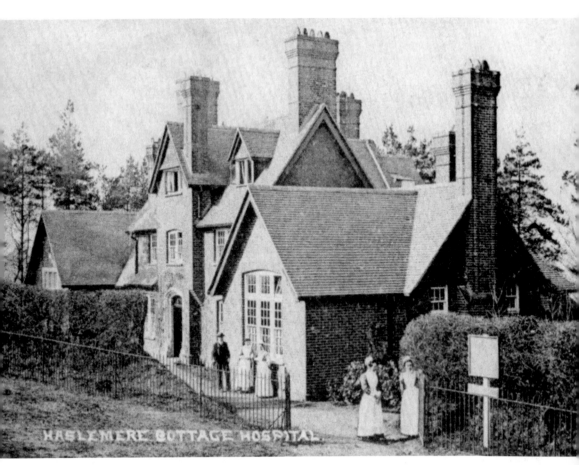

HASLEMERE COTTAGE HOSPITAL was built at the top of Shepherds Hill and opened by the Lord Lieutenant of Surrey at 4 p.m. on 11 June 1898. The hospital was the most generous gift of John, Susanna and Kate Penfold as a memorial to their parents and to commemorate the Diamond Jubilee of Queen Victoria. When first opened the hospital had four beds in the care of the matron Miss Johnson but demand soon exceeded supply and the building was extended to provide places for two more patients. During a management meeting held at the rectory on 23 August 1898 it was agreed that patients should contribute from 5 s. per week towards the cost of their stay. Local fund-raising to support the hospital included a grand theatrical entertainment at the White Horse Assembly Room in November 1898 with seats priced at 5 and 10 s. for the afternoon performance, more in the evening. The scenery was painted by the artist Charles Whymper who lived in Petworth Road, and Mrs Ernest Aves, sister of Mrs Leesmith from Houndless Water, conducted the small orchestra. The sign outside the hospital gate in 1910 read Haslemere and District Cottage Hospital. Visiting Hours, Sundays, Tuesdays, Fridays. Hours 2 to 4 o'clock, a time when visitors were regarded more as an inconvenience to the staff than a benefit for the sick. At this time the matron was Miss Amelia Stone who was succeeded around 1905 by Miss H. Neve. The last matron, Miss Davenport McPhee, came from Church Hill Military Hospital in 1919 and moved to the present hospital when this opened four years later. The old hospital on Shepherd's Hill is now called Anderson Court.

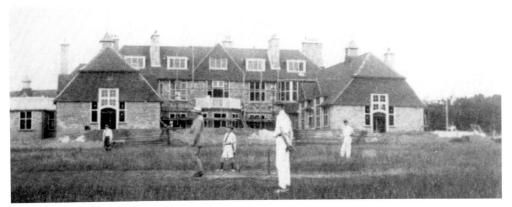

HASLEMERE AND DISTRICT HOSPITAL was opened in January 1923 by Viscount Cave, CMG. The first matron was Miss Davenport McPhee who had previously been in charge of the Cottage Hospital. When the new hospital first opened there were only two wards, one for men and the other for women but by 1930 a third ward for children was built with money raised by public subscription. Before the hospital was built by Chapman, Lowry and Puttick, the land had been the Pound Corner Recreation Ground. A new site was found for a short time at the top of Shepherds Hill but soon moved when the present ground was provided by the War Memorial Committee.

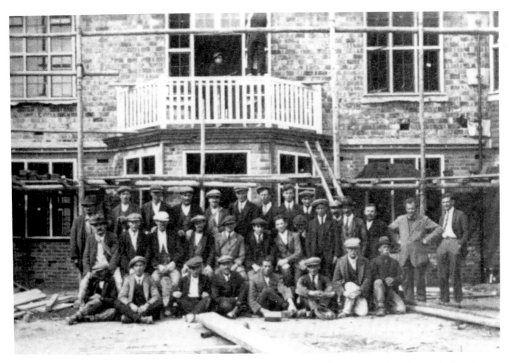

A GROUP OF WORKERS from Chapman, Lowry and Puttick outside the front of the almost completed Haslemere and District Hospital. Among the men in this photograph are Wilfred Harris (foreman) second from right with hands on hips, Alf Holden (carpenter) next right, Horace Harmer (plumber) fifth from right, head only, and Bill Pettis (bricklayer) fifth from left in middle row.

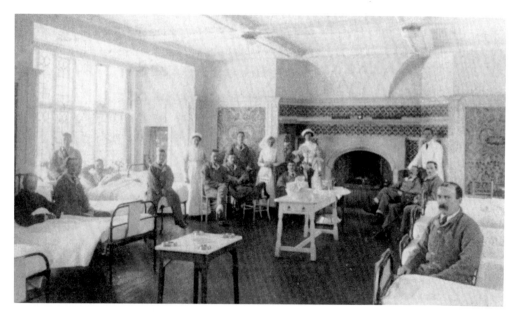

DURING THE FIRST WORLD WAR several of the larger houses in the district were used as Auxiliary Medical Hospitals, one of these was Hilders, Surrey home of Lord Aberconway since it was built around 1897. The house which stands between the Hindhead Road and Lion Lane was Branksome Hilders School for Boys, started in the late 1930s by Sydney H. Smith. Later in the 1990s it belonged to Olivetti and is now the Branksome Conference Centre.

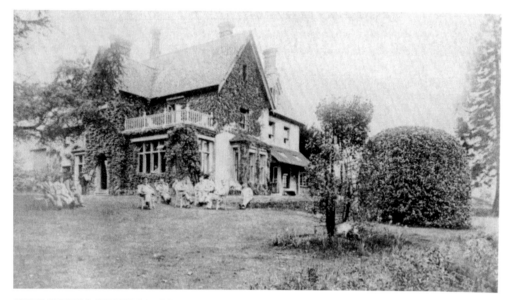

CHURCH HILL HOUSE MILITARY HOSPITAL was opened in March 1917. The matron was Miss Davenport McPhee who moved to the cottage hospital in 1919. The house had been built by the Revd. Richard Parson in 1860 on the site of Church Hill Farm. When war was declared in 1914 it was occupied by Mrs Easton Allen. The house is now known as Peperham House – a link with the twelfth-century chapel that became St Bartholomew's Church (see p.23).

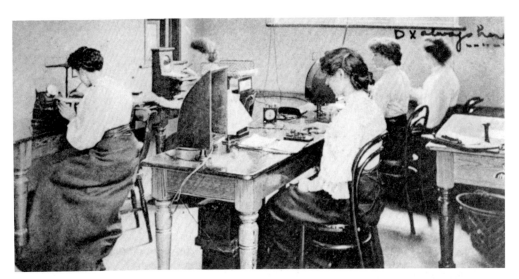

BEFORE TELEPHONES became readily available as a means of long-distance communication many post offices had a telegraph machine used for sending and receiving messages in morse. The telegram was often delivered over the last part of its journey by a telegraph boy on a bicycle (see p. 37). The postcard above shows the telegraph room at the new West Street post office when it opened in 1906. The following year the first telephone service in Haslemere opened with fourteen subscribers.

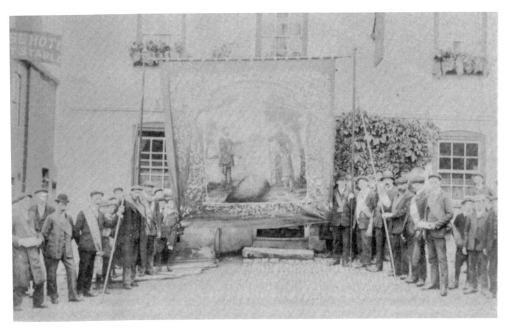

THE ANCIENT ORDER OF FORESTERS was founded to provide benefits for members who were sick and unable to work. The local Court Pride of Hindhead was established in 1883 and a group of members are seen here with their colourful banner outside the Kings Arms. Turner Bridger, a founder member, was secretary for more than twenty-six years during which time £3,171 was distributed to the members.

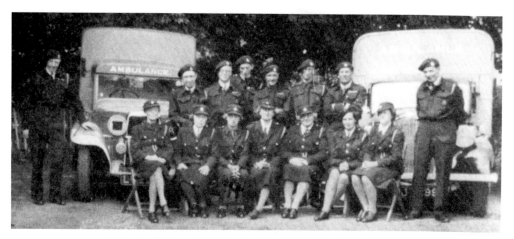

DURING THE SECOND WORLD WAR the local ARP ambulance service operated from a depot at the end of Pathfields in Church Lane, Haslemere. Present at the stand-down parade in 1945 were back row, left to right: Superintendent Hunter (standing), Harris, Duncan, Brown, Reynolds, Holmwood, Smithers. Front row: Minton-Senhouse, Irish, Methuen, Griffith, Waters, Reah, Kitto and Phillips (standing). Sadly, ambulance driver Marion Clarke had been killed on 8 March 1943 when splinters from one of a stick of high explosive bombs badly damaged the depot.

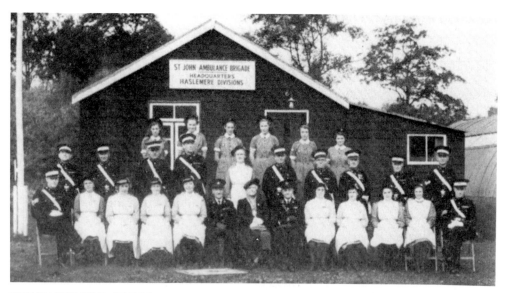

THE HASLEMERE, SHOTTERMILL AND HINDHEAD branch of St John Ambulance Association was founded in 1904 by Dr P. Strong with Mr E. Gane Inge honorary treasurer. Forty-five years later the new headquarters of the Haslemere Division of the St John Ambulance Brigade was dedicated on 1 May 1949 with a service on St Christophers Green. Outside the hut behind the drill hall are back row, left to right: Jean Stewart, Barbara Hill, Elizabeth Towner, Doreen Standing, Gwen Rudderham, Brenda Cook. Middle row: George Mills, -?-, Stiles, Harry Brown, Mrs Roe, Bill Boxall, Arthur Mills, -?-, -?-, -?-. Front row: -?-, Miss Doxey, Gwen Irish, Mrs Dickenson, Miss King, Billy Brown, Mrs Fearon, Mr Knight, Minnie Mills, Violet Kevan, Jean Boxall, Jean Rothwell, Jack Knight.

SECTION ELEVEN

Shottermill

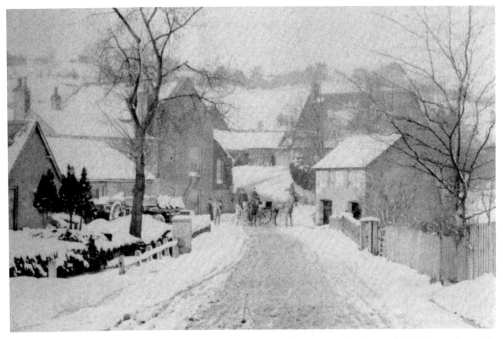

THERE WERE FOUR WATER-MILLS on the River Wey between Sicklemill and Critchmere but only Harry Oliver's mill at Shottermill was engaged in grinding corn. The grindstones were turned by an overshot waterwheel until 1870 when this was replaced by a turbine. Milling ceased in the 1920s. The mill is seen here after the blizzard that swept across southern England on 25 April 1908. The large wagon on the left belonged to the coal merchant Augustus West who operated from yards at Haslemere station and Hindhead. The store and cart shed opposite the mill was demolished about forty years ago.

GEORGE 'CURLY' RAPSON was the blacksmith at Lion Green from 1875, when he moved there from Lurgashall, until he died in April 1912. Until just after 1900 he and his family lived in one of a row of cottages that were demolished to make way for Kingsdale and his forge stood nearby (see p. 127). He was closely involved with the church, being parish clerk at Shottermill for more than twenty years, and a member of the Workmen's Club, Sports Club and the Ancient Order of Foresters. He is seen here with his wife Jane and their seven children, left to right: Charlie, Harry, Walter, Percy, Alfred, Florence and Edwin.

THE CHUTER FAMILY around 1870 outside the double-fronted Georgian house called Linton, next door to the Red Lion and overlooking what is now Lion Green. John Chuter, and later his son Stanley, was a coach builder and the small building to the left, just visible behind the house, was the forge where the iron tyres were put on the wheels. After returning from the army in 1919 Stanley moved to Critchmere where he eventually went into partnership with Mr Hills. Chuter Hills are still coach repairers to this day. Linton was later divided into two separate houses before being demolished to make way for the Co-op supermarket in 1980.

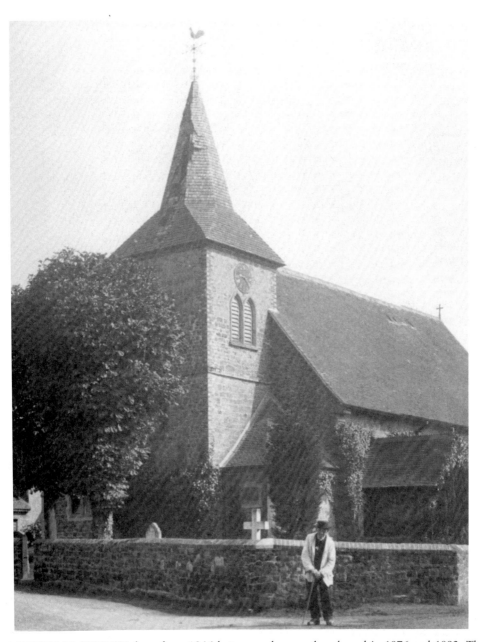

ST STEPHEN'S CHURCH dates from 1846 but was subsequently enlarged in 1876 and 1892. The church was then restored in 1897 and in 1910 a new aisle was added. The ecclesiastical parish of Shottermill was formed in July 1847 and was created a civil parish from Frensham in October 1896. The parish clerks during this period of change were James Etherington followed around 1890 by George Rapson, the blacksmith from Lion Green (see opposite). On his death in 1912 he was succeeded by his son Alfred who was parish clerk when this damage was caused by lightning to the wooden shingles covering the spire on 15 August 1915. Today this view is partly hidden by the war memorial erected to honour the brave young men of Shottermill who gave their lives in two world wars.

LION LANE before the arrival of the motorcar. This is the view from outside Shottermill Middle School as it was in the early 1900s. Many of the houses had been built during the previous ten years but more development was still taking place in 1906 (see p. 134).

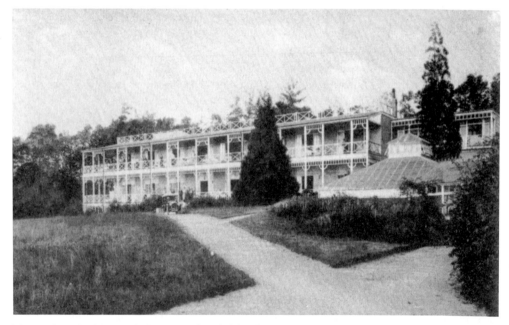

THE HOLY CROSS HOSPITAL was founded by the Congregation of the Daughters of the Cross in 1917. It is centred around Shottermill Hall, for many years the home of Miss Foster, one of the principal landowners in the village since the 1890s. The hospital was built originally as a sanatorium for sufferers from tuberculosis, a common disease at that time. Patients were confined to bed but treatment also required plenty of fresh air, hence the open balconies and wards evident in this 1923 view. The original sanitorium has now been demolished and a new hospital block built on the opposite side of Shottermill Hall.

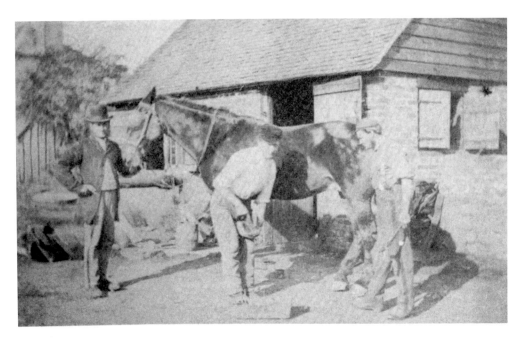

GEORGE RAPSON the blacksmith at Lion Green is seen here around 1890 shoeing a horse outside the forge which stood almost opposite the green. He is being helped by his son Alfred who was later to succeed his father both as blacksmith and as parish clerk at St Stephen's church. Alfred died in the 1930s and the forge then became a fruit and vegetable shop run by his younger brother Charlie. Later in the 1960s the building (below), which had been extended in length at some time since the top picture was taken, was used as an antique shop until it was demolished to make way for the new Methodist church. The cottages just visible to the left in the earlier picture were demolished when Kingsdale (now called Chestnut View) was built.

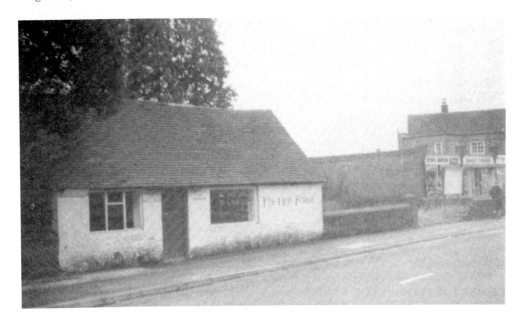

HASLEMERE, SURREY

Particulars, with Plan, and Conditions of Sale

OF THE DESIRABLE

FREEHOLD & COPYHOLD PROPERTY

Exceedingly well situate about threequarters of a mile from Haslemere Railway Station, and about one mile from Haslemere Town, comprising the

Valuable Water-Power Mill

WITH AUXILIARY OIL ENGINE POWER.

KNOWN AS

"SICKLE MILL."

Premises well adapted for Manufacturing or Laundry purposes; there is a supply of the purest soft spring water flowing into the Mill from several springs. Electric Light has been installed, driven by water power.

Attached to the Mill is

A PICTURESQUE RESIDENCE

Surrounded by LAWN and excellent GARDEN; containing 13 rooms; there is STABLING, GARAGE, and other OUTBUILDINGS.

The "Sickle Mill" Pond

Forms a beautiful head of water extending over several acres, and is a pretty feature to the Property.

There are

FIVE COTTAGES

Conveniently situate, producing £57 4s. a year. The whole Property extends over an Area of nearly

EIGHT ACRES.

WHICH WILL BE SOLD BY AUCTION BY

MESSRS. MELLERSH

(Under instructions from Messrs. Appleton) at

THE LION COUNTY HOTEL, GUILDFORD,

On Tuesday, the 18th day of July, 1911

At FOUR o'clock precisely, in ONE Lot.

MESSRS APPLETON, who also manufactured braid at Elstead, sold Sickle Mill at auction in 1911. Later in the 1920s the mill and cottages were bought by the local authority.

SICKLE MILL was owned by James Simmons who made paper there until 1870. Through the second half of the century Henry and Thomas Appleton manufactured braid for decorating military uniforms. The garage now in front of the mill was used for the local ambulance after the Pathfields depot was damaged by a bomb. After the war county council ambulance drivers were assisted by volunteers from the St John Ambulance Brigade who were paid the great sum of 4 *d*. per hour for this service.

STURT ROAD around 120 years ago. The entrance to Sturt Farm is just visible to the left, the gate on the right is where Sturt Avenue now drops down the steep bank into Camelsdale. In 1907 a borehole was sunk here to supply the people of Haslemere with piped water from the reservoir built on Blackdown and opened that November. Until the middle of the eighteenth century this was probably the route used by coaches from London on their way from Hindhead down to Chichester (see p. 33).

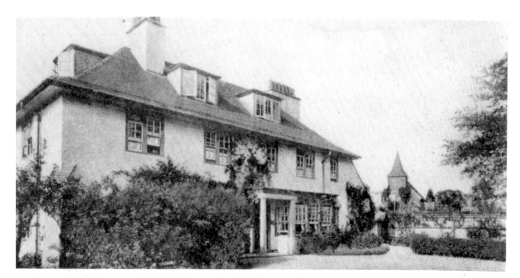

THE THREE COUNTIES ASSOCIATION NURSING HOME at Shottermill in 1913. The original home was founded in 1897 by the Revd John Wallace and the Misses Wallace to provide ten nurses for the poor and middle classes and was in a house later called The Thicket (see below). The larger house was built in 1906 near St Stephen's church. Later it became a private house but has recently been demolished. The building of Shottermill House on this site opposite the church has destroyed another corner that still had the rural appearance for which the Haslemere area was once well known.

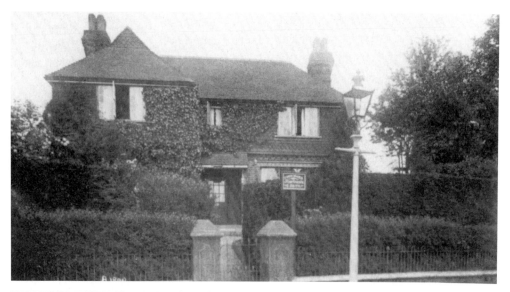

TOURISTS VISITING THE AREA when it became popular earlier this century needed accommodation and many hotels and guest houses were advertised in local guide books. At Shottermill around eighty years ago Mrs G. Smith offered apartments at The Thicket next to St Stephen's church. This house was more recently used as a doctor's surgery and is now offices, with the walls and hedges removed to allow car parking. Close by Shottermill Club, originally the Working Men's Club, began its existence as Shottermill School. Later the school moved to Lion Lane and the building was used for the wholesale distribution of confectionery.

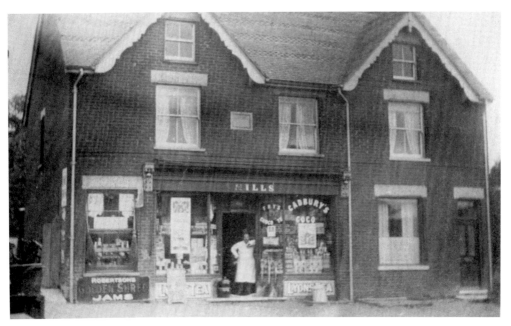

MILLS GROCERY SHOP at Junction Place, the original name of the buiding but now used for this corner of Shottermill. George Mills senior was already trading in 1887. After he died the business was continued by his widow Kate until their son George took over and kept the shop open into the 1960s. Note the besom or birch brooms perched on the windowsill, probably made nearby in Shottermill or Hammer; there were still several working broomsquires close by, the nearest being in Underwood Road.

A VERY RURAL SCENE at Shottermill Ponds in the 1930s. The ponds are actually in Sussex and at this time Lynchmere war memorial stood on a triangular grassy island between the roads to Haslemere, Camelsdale and Liphook. In the background the two ponds, now owned by the National Trust, once supplied extra power to the waterwheel at Oliver's Mill, the main source being provided by a leat diverted from the River Wey through a sluice below Camelsdale Recreation Ground. The flow in this leat is now reversed with the water running from the ponds into the river.

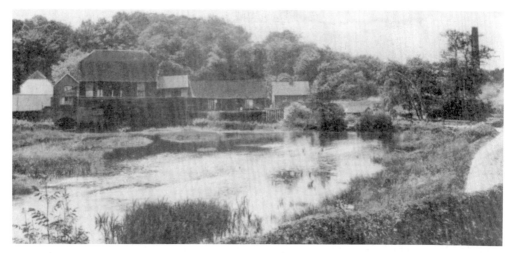

NEW MILL in 1914. The mill was situated just south of the railway line and adjacent to the sewage treatment works off Critchmere Lane. It was one of the three mills owned by James Simmons and was producing paper around 1800. Later leather was processed in conjunction with Pitfold Mill and in 1918 it was used for rearing rabbits. The pond silted up during the 1930s, the mill was demolished in 1976 and only the sluice now remains.

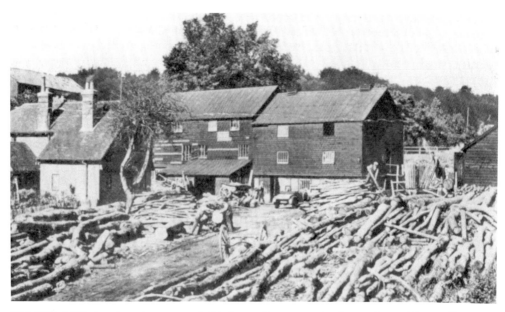

PITFOLD MILL stood at the corner of Critchmere Lane opposite the turning to New Mill. During the nineteenth century it belonged to the Simmons family but when James Simmons died the mill was sold in 1903 for £750. It had been used as a leather dressing works but from around 1906 the Stanley Underwood Company began producing chestnut fencing and this was continued by Jimmy Homewood from 1951. When the mill was sold again Homewoods moved to the old coal yard at Wey Hill from where Steve Homewood is still supplying chestnut fencing today. Pitfold Mill has since been demolished and houses built at the corner of Critchmere Lane.

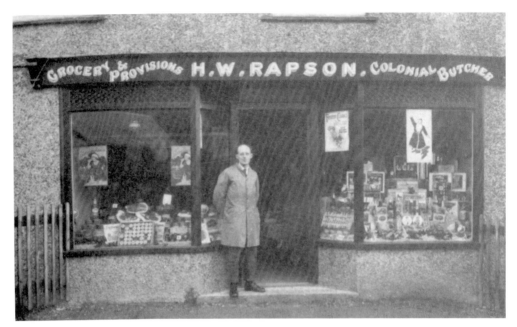

HARRY RAPSON was a grocer and butcher whose small shop stood at the corner of Critchmere Lane opposite the Royal Oak. Harry was the fourth son of George Rapson the blacksmith at Lion Green (see p. 124). He retired around 1950 and with his wife Lily moved away to live near Portsmouth. The shop in Critchmere later closed and is now a private house.

THE JUNCTION OF Nutcombe Lane with Hindhead Road around 1935. The present entrance to the Branksome Conference Centre is where the road kinks to the right, but the drive of Hilders School which preceded the present training centre was located on the bend at the bottom of the hill. Further back between Critchmere Lane and the entrance to Frensham Hall Farm the road had been so narrow that for about 150 yards there was room only for one-way traffic, vehicles having to wait at either end while those from the opposite direction passed through. This state of affairs continued until the boundaries of Haslemere were extended in the 1930s to include Hindhead and Beacon Hill; the road was then widened by cutting back the bank.

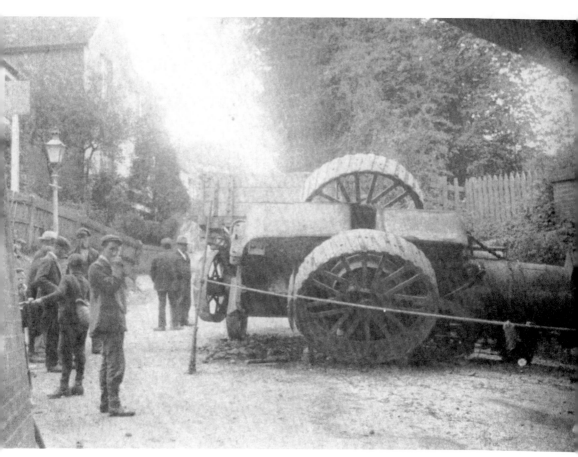

THE WRECKAGE OF A BURRELL TRACTION ENGINE belonging to Mr George Ewen, a haulage contractor from Petersfield, finished up partly blocking the road under the railway bridge by Critchmere Lane. The traction engine had been travelling backwards and forwards from West Liss to Shottermill delivering 6,000 bricks at a time to a site in Lion Lane where Mr Marshall was building houses. Returning with two empty wagons on Monday 25 June 1906 the differential pin worked loose making the steering gear inoperable. The engine careered down the hill from St Stephen's church, swaying from side to side as the driver, Alfred Privett, tried to keep the vehicle under control. However, before it reached the bridge the engine hit the bank, snapping a tree before turning over. The collision knocked off the front wheels of the traction engine and shattered the steam valve, allowing a large quantity of steam to escape with a loud noise. The driver was luckily only slightly injured and was taken to the cottage hospital after treatment by Dr Roger Hutchinson. His mate, William Dennis, and the engine-owner's son, who was a passenger, were both unhurt. The local police forces attended in strength, led by Superintendent West from Godalming with Sergeant Stevens and Constables Bettisson, Small and Matthews from the Sussex Constabulary. The road opposite the Staff of Life public house remained partly blocked until another engine removed the wreckage to Haslemere railway station the following day. The Burrell had cost £580 around 1897 but after the accident was sold back to the manufacturers for £80. We wonder if Mr Ewen was insured.

SECTION TWELVE

Wey Hill

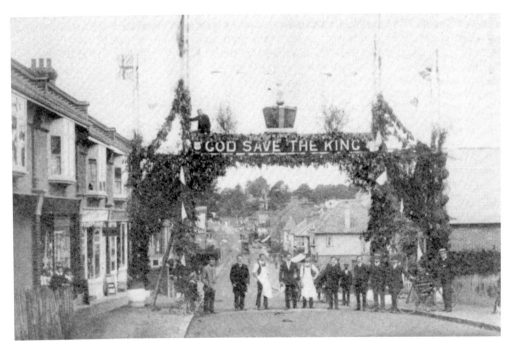

CELEBRATING THE CORONATION of King George V and Queen Mary on 22 June 1911 involved building an impressive arch of greenery across the road outside Parminter's sweet shop, now Haslemere Travel. The archway was constructed by local tradesmen who included the saddler William Duck (second from left, dark clothes) whose shop was at No. 89. Next to him is Mr Upfold, an upholsterer who worked for Arthur Bartlett at what is now Farnham Carpets. Walter Queen, bootmaker, is third from left of the bicycle belonging to pork butcher D. H. Higlett, whose shop at the corner of St Christophers Green is now a gentlemen's hairdressers.

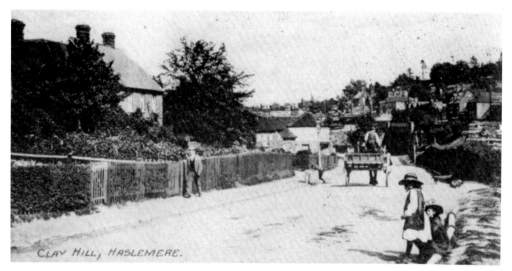

CLAY HILL, HASLEMERE.

LOOKING EAST towards the Crown and Cushion where in 1908 the landlord Thomas William Newman was also a coal merchant, where Homewood's office and yard is now. On the right Clay Hill Chambers, home of the Haslemere and District Industrial Co-operative Society Ltd for around sixty years, is being built to replace their first premises in Lower Street. The manager at this time was Mr Britton W. Acton.

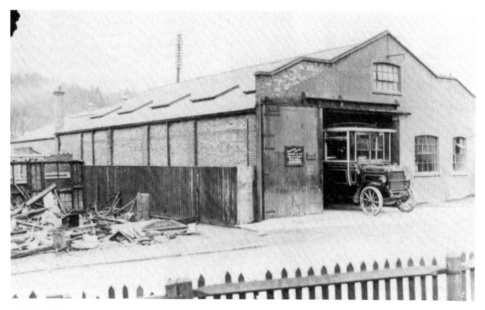

CLAY HILL BUS GARAGE in 1920 was almost damaged by fire when the wooden hut next door, used as a surgery by dental worker Mr Roderick H. Maclean, was accidentally burnt. The alarm was raised by Mrs Tickner who was returning home from a Women's Guild party at the Co-operative Hall (opposite Crowns). The Co-op manager, Mr F. Waters JP, soon organised an army of water carriers, including drivers and conductors from the bus garage. The building, which had until the year before been used as a photographic studio by Mr Williamson, was completely destroyed (see p.47).

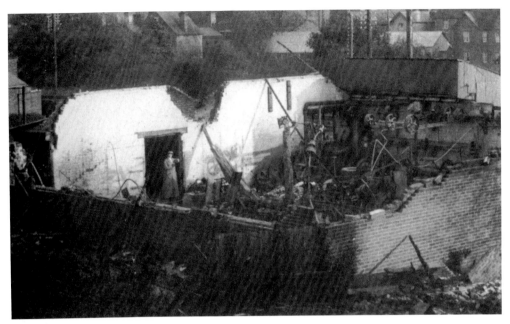

THE ROYAL HASLEMERE LAUNDRY was built on Wey Hill in 1909 by Mr and Mrs John Smith who sold it to Frank Milton in 1911. Two years later on 1 November 1913 the laundry was destroyed by a fire thought to have been started by a firework. The manageress, Miss E. Parker is standing in the doorway surveying the damage estimated at £2,000. The laundry was rebuilt and existed here until about ten years ago when it was demolished and the site was redeveloped as a retail wine warehouse. The gasometer and smoking chimney behind the laundry are the Kings Road gasworks opened in 1869 to supply piped energy to the town.

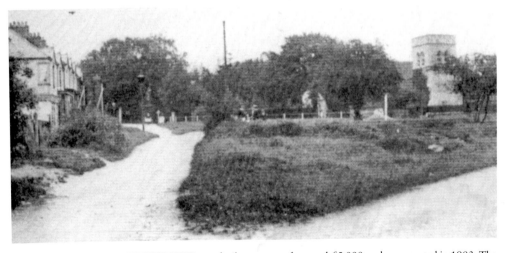

THE CHURCH OF ST CHRISTOPHER was built at a cost of around £5,000 and consecrated in 1903. The first minister was the Revd Allan Macnab Watson. Before the church was built services had been held for the overflow congregation from St Bartholomew's in a corrugated iron mission room in Kings Road. These services had been conducted by the Revd Leake, but in 1902 he became the fist vicar of Grayswood.

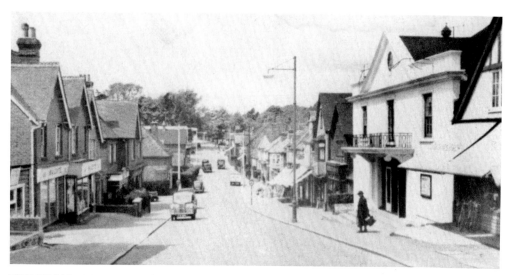

THE REGAL CINEMA was built by the Haslemere Cinema Company part way down Wey Hill and had opened by 1915. After the First World War it was enlarged but in 1936 the same company opened the Rex Cinema and the Regal was closed in 1938. After the Second World War the old cinema was used to display new Vauxhall cars available from Farnham Lane Garage. Kinema Cottage next to the cinema had one room open as a small shop but in the 1960s both were demolished and new shops built, including the first supermarket in the town.

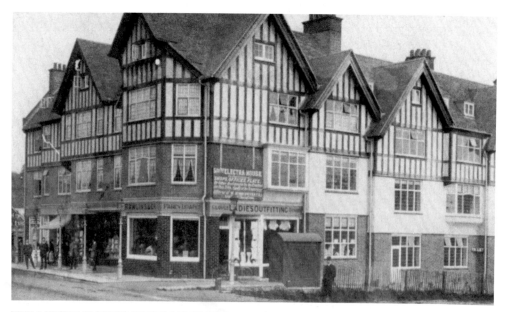

THE MOST IMPOSING DEVELOPMENT prior to the First World War was Electra House, the block of the shops, offices and flats built in 1911 by John Grover. One of the first people to occupy an office was his son-in-law Arthur Cherry, secretary of the Hindhead and Haslemere Electric Light Co. Ltd. The new electricity sub-station, outside the drapery of Rawlins & Co, provided power for the row of six street lamps in front of Electra House. This building is now called Clay Hill House.

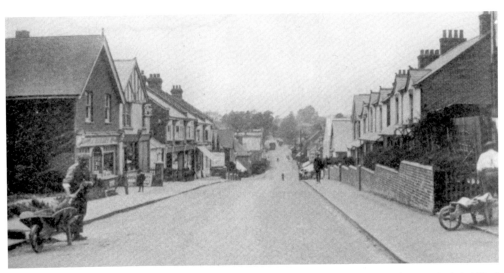

WEY HILL soon after the Regal Cinema was built since it is just visible on the right. On the left Alfred Harden's confectionery shop was a favourite haunt of local children. It was later demolished when the Haslemere Co-operative Society added a furniture department to their drapery and hardware stores on the corner of St Christophers Road.

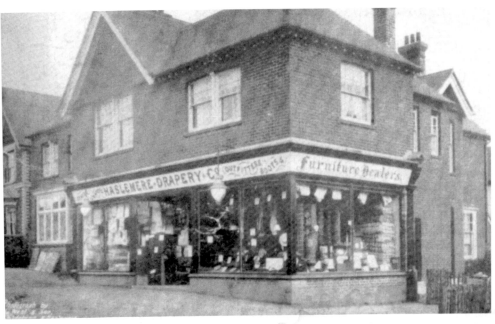

A BUILDING with a short but varied history. Opened first as a drapers by John Humphrey, the shop then became a grocers kept by Mr Rossi. During the last war it was requisitioned and used to billet soldiers, who were fed at the British Restaurant run by volunteers under the supervision of Mrs Capner at St Christopher's Hall. In November 1947 the present County Library was opened by Mr Thorold Harper, chairman of the County Library Committee, replacing the two local branches that had been opened two days each week by volunteers.

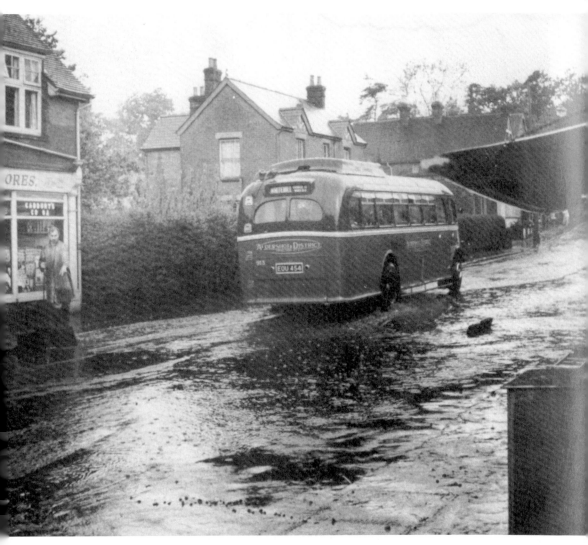

FLOODING at the bottom of Wey Hill was an irregular but annoying event after heavy rainfall. This situation was made worse if the rainwater gullies in Farnham Lane and Lion Lane were blocked by fallen leaves, when the surface water drained to the lowest point at the bottom of the hill. George Winter (left) looks rather bedraggled having just experienced the wash of a passing Aldershot & District bus while trying to stop water flooding into Irish's Stores. A few years later the slight kink in the road was straightened out and a new and larger diameter culvert put underneath, giving the water that collects here an escape route into the stream. The Dennis Lancet III bus is partly obscuring a double-fronted house called Oakleigh which was the new home for blacksmith George Rapson and his family soon after 1900. After he died in 1912 the house became home for Charlie 'Devvy' Rapson and his wife Kit. During the late 1950s and early 1960s plumber Len Bartlett and his wife were the last occupants of the house before it was demolished and replaced with a row of four shops and flats. The stream at this point is the boundary between Haslemere and Shottermill with most of this scene in the latter parish.

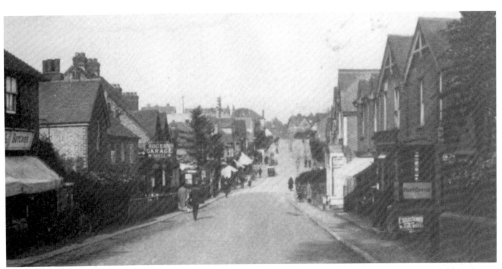

LOOKING UP WEY HILL from Lion Green in 1925 the majority of shops and houses apart from Bell's butchery had already been built. To the right behind the stone wall there was a pair of cottages. The café, just visible on the extreme right, was popular in the 1960s when local motorcyclists raced round the town to beat the record playing on the juke box.

H. J. ROGERS,
Station Road,
Shottermill,
HASLEMERE.

PURE

FOUL

RUNNING TO WASTE

MANUFACTURER OF THE

"Roberts" Rain=Water Separator
(Rejects the Bad and stores the Good Rain Water),

As supplied to H.M. War Office, Government of India, County Hospitals, Poor Law Unions, &c.

PRICE LIST AND PARTICULARS ON APPLICATION.

CYCLE AGENT and REPAIRER. High=grade Machines for Sale or Hire.

Terms moderate.

HARRY ROGERS' BUSINESS was established soon after 1900 on the north side of Wey Hill. By 1925 his cycle shop had also become a garage (see above) with access alongside the premises which are now occupied by Occasions. The shop also sold phonographs and records; later it became an electrical shop until around 1980. Mr Rogers was assistant overseer and clerk to Shottermill Parish Council. He is still remembered for the active part he took in church life and for his voice in the choir.

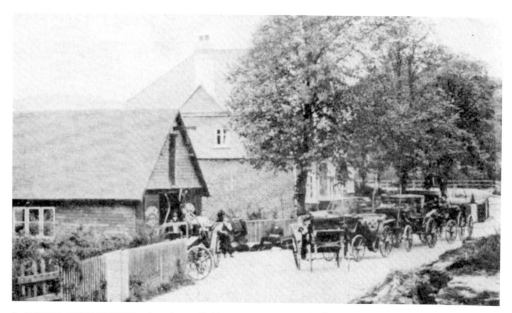

J. VOICE, JOBMASTER, showing off his many traps and flies outside the coach house in St Christophers Road around 1905. These were available for hire to take people around the district, the forerunner of today's taxi service. Nextdoor Mrs Voice offered visitors accommodation at Barrington House and no doubt many of her customers were met at the railway station by her husband. After the Second World War the taxis and limousines of Fox & Styles were garaged here. Now the large doors have been replaced by a bow window filled with fancy dress costumes at the Haslemere Wardrobe.

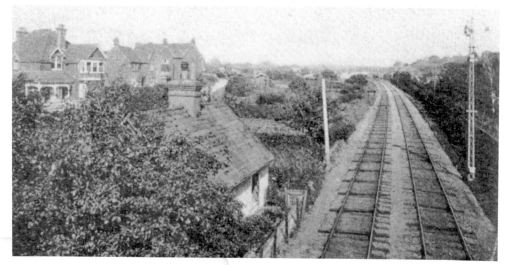

LOOKING TOWARDS THE STATION from the new Sicklemill footbridge in 1905. Until around 1903 there had been a level crossing here and the small cottage in the foreground was occupied by the gatekeeper. Glenside (left) and the other houses on the north side of St Christopher's Road had already been built by this time but not those between the railway and the road. Neither had St Christopher's Hall which was built in 1912 and demolished in 1983.

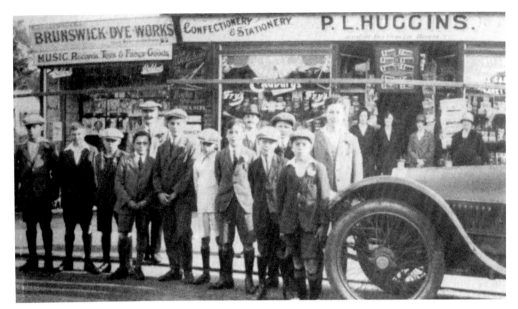

EACH SUMMER during the 1920s the delivery boys from Preston Huggins' newsagents shop went on a charabanc trip to the seaside, a tradition begun by his predecessor, Alfred Sewell. In the picture are, front row, left to right: George White, Walder, Ernest 'Snowy' Mansbridge, Ron Heather, Sid Madgwick, Lambdin, Stallard, Lambdin, Fred Stevens. Second row: -?-, (played the piano at the Empire), Mr Huggins, Jack Pickaver, Johnny Frogley. Back row: -?-, Nancy White, Kathleen Sadler, Margaret Waters. The other shop mentioned on the facia board, Beethoven House, was a little further up the hill and is now a café.

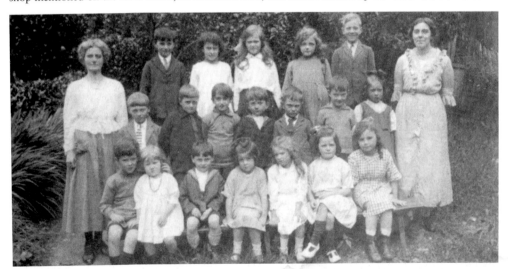

MISS ZILLAH FORD (left) ran a school at Upton Cott, St Christophers Road with Miss Lilian Welland (right). Pupils around 1922 included back row, left to right: -?-, Rene Bridger, Betty Bucket, Ruby Irish, ? Papps, Middle row: ? Smith, -?-, Ronnie Stroud, Cyril Queen, -?-, -?-, Clarice Bromley. Front row: Peter Madgwick (first) and Connie Stroud (fourth). Later Miss Ford moved to Meadow Vale. Miss Welland taught at Green Bushes School and later opened Hillside School behind the first shop on the left in Petworth Road.

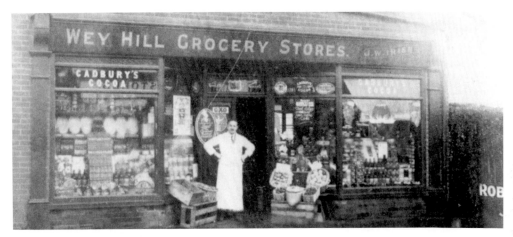

JOHN IRISH built his shop on the corner of St Christophers Road and Wey Hill and opened for business on 1 January 1909. For several years before, Arnold and Irish sold both meat and groceries just along the road in a shop which is now part of Lloyds Bank. John Irish died in 1937 but the shop remained a family business, kept first by his widow Florence (née Rapson, see p. 124) and from 1958 by her son-in-law and daughter George and Ruby Winter. During the 1940s and 1950s many people remember listening outside the shop during the evening as Leslie Irish played the piano upstairs. Irish's was demolished soon after it closed in 1973.

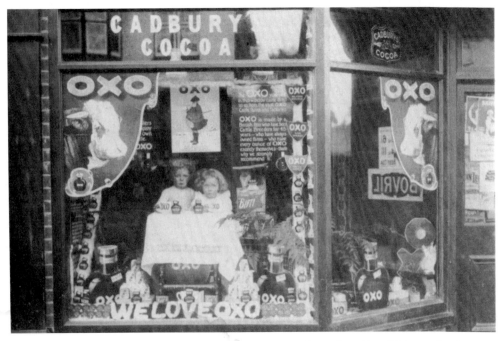

A COMPETITION to promote the sale of Oxo in 1911 gave John Irish at Wey Hill Stores the chance to show of his skill as a window dresser. Posed in the window are his eldest children Leslie and Gwendolene, photographed by E. T. Williamson who had a wooden studio between the bus garage (later Clement Brothers) and the old Haslemere Co-op Stores (Haslemere Motorcycles until 2008) at the top of Wey Hill (see pg.136).

SECTION THIRTEEN

People at Work

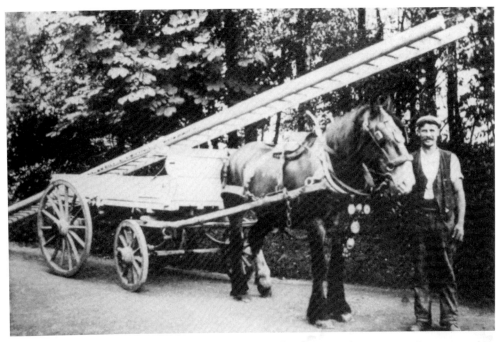

EARLY THIS CENTURY two Grayshott builders named Chapman and Lowry went into partnership. By 1907 they had been joined by a painter called Puttick and a firm of building contractors was born that became well known throughout the area for over seventy-five years until it closed in 1986. This early picture shows a very long ladder being taken to a building site. Among the larger local buildings put up by Chapman, Lowry and Puttick Limited were the police station in West Street, the Haslemere Hospital in 1923, the Rex Cinema in 1936 and the Methodist church in 1972 at Lion Green.

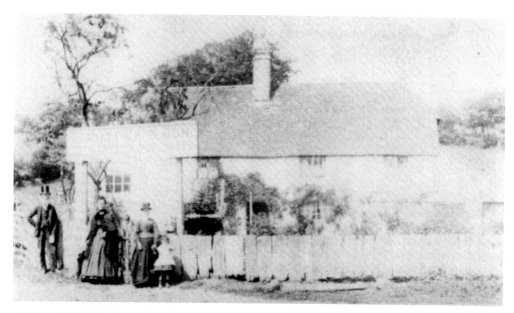

BENJAMIN PUTTICK and his family are standing outside their home, Fleur de Lis, at Carpenter's Heath, Bell Road, where he and his son were timber merchants during the latter part of the nineteenth century. Soon after 1900, Jesse Mann from Cranleigh bought the house and the sawmill. The business continued until 1997 when it became Coombers. Fleur de Lis was painted by Helen Allingham and this picture is now in the Victoria and Albert Museum at South Kensington.

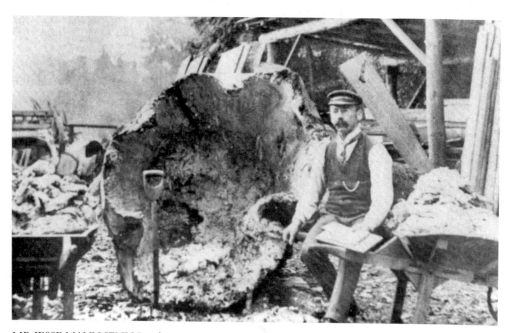

MR JESSE MANN SENIOR, who came to Haslemere and established his business as a timber merchant soon after 1900, is seen here scooping decayed wood from a large oak butt.

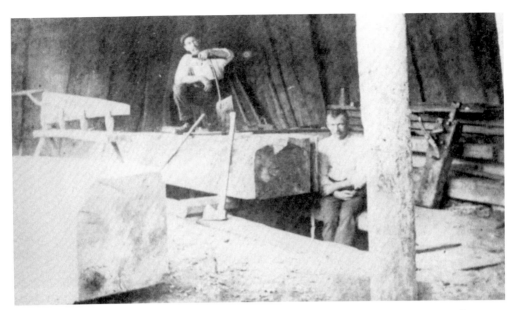

SAWING ELM COFFIN BOARDS with a pit saw was still the method used when Jesse Mann first came to Carpenter's Heath early this century. The top sawyer was Percy Penycard (left) and the less fortunate underman who endured miserable working conditions in semi-darkness pulling the saw down through a rain of sawdust was James Ayling.

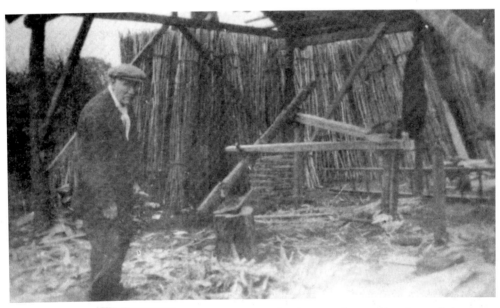

OLD STEVE PUTTICK was the last of the local cleavers who spent his working days splitting green rods with a froe. He worked in an open shed on the edge of Jesse Mann's yard where he lived in an old car body. He was a very private person who always stopped work if anybody was watching him. Reputedly a man of few words, he used to say on Mondays 'Good morning for the week' to the other employees at the timberyard.

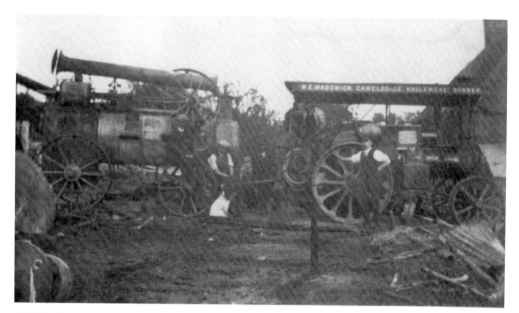

FIRE IS AN EVER-PRESENT DANGER IN A SAWMILL. In 1921 there was a tremendous fire at Jesse Mann's timberyard. The fire was discovered at 2.15 a.m. by his son Stanley who slept at the rear of Fleur de Lis and was awakened by the heat. His brother David was sent to the gasworks in Kings Road to raise the alarm. The fire brigade led by Chief Officer G. W. J. Clark arrived within sixteen minutes of the alarm sounding. But by this time the whole timberyard was in flames and some roof rafters in the house were also starting to burn. The fire in the roof was soon extinguished but most of the yard and timber was completely destroyed. The yard was by the last hydrant in Haslemere but water was soon being pumped from the stream using a steamer. Damping down continued until 9.15 a.m. Later W. E. Madgwick from Camelsdale used his traction engine to pull the badly damaged sawmill engine from the wreckage. The timberyard was rebuilt on the opposite side of Fleur de Lis where Coombers still supply timber from these buildings.

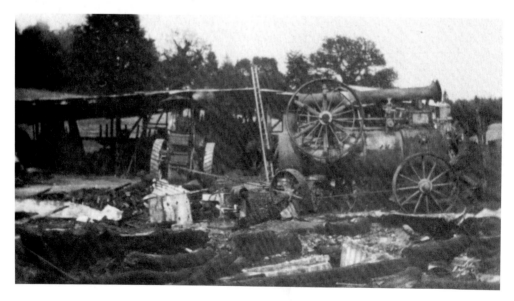

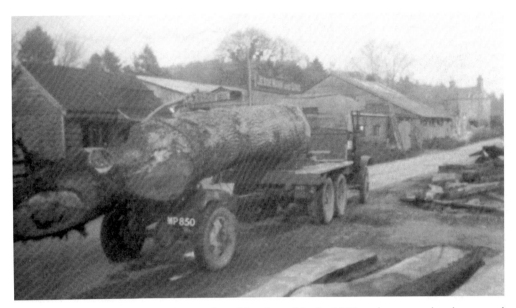

ANOTHER ENGLISH OAK arriving at Jesse Mann's yard in the 1950s to be seasoned and converted into fine quality boards. Trunks waiting to be sawn into timber were stacked on the narrow grass strip between the roads in front of the sawmill.

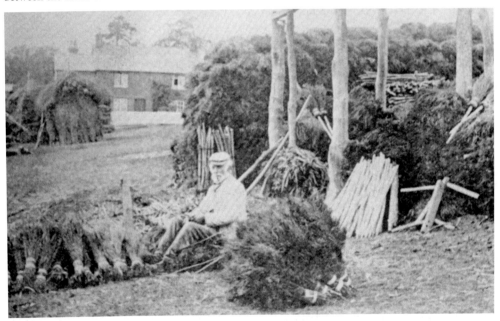

THE BROOMSQUIRES of the local heaths were famed for their besom brooms made from bundles of birch twigs, bound together with either pieces of bark, strips of pliant material such as thinly split willow or even bramble stems, then fixed to a short wooden handle. Many of the besom brooms were taken up to London by horse and cart. Local makers included William, George and Edward Moorey, as well as George Berry, Albert Edwards and Charlie White, above, working around 1900 outside his cottage in Hammer Vale.

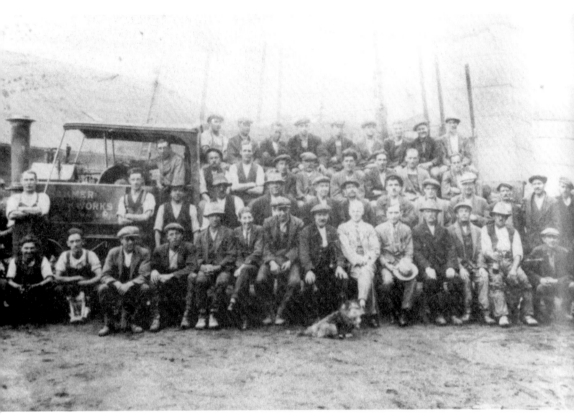

HAMMER BRICK AND TILE WORKS was developed by John Grover (see p. 60) in the early 1900s from a small brickworks that had been in the area at the end of the nineteenth century. John Grover brought in experienced men such as his manager, Moses Young, from the brickworks at Tunbridge Wells. For a time day was dug at the top of Wey Hill, hence its former name of Clay Hill, from a pit which is now the car park and fairground next to Electra House, now called Clay Hill House. The clay was then taken to Hammer. Some years after this source of clay was worked out the brickworks still had an office at Wey Hill. In the 1920s Len Young succeeded his father as manager, but he died in 1928. Hammer Brickworks continued in production until 1936 when the supply of Atherfield clay was worked out, the pit being surrounded by the River Wey, the railway and the houses in Copse Road. One of the workers, Eddie Keemar, remembers then being transferred to the Hambledon brickyard where he checked bricks before they were sent back to Hammer. The works were finally closed down in 1938 by the Nutbourne Brick Company but bricks marked 'Hammer' or 'Grover' are still sometimes found around the area. The group above was taken at the brickworks around 1921. They are back row, left to right: Albert Hill, Sammy Ward, Eddie Keemar, Arthur Etherington, George Saunders, Tom Saunders, Digger Silk, Arthur 'Tuggy' Boxall, Arthur Wheeler. Second row: Wesley Puttock (in lorry), Ben Keemar, Abraham Brunt, Reg Thayre, Bond, Tom White, Goff White, Arthur Gauntlett, Benny Keemar. Third row: Arch Hill, George Puttock (at front of lorry), Percy Puttock, Denyer, Madgwick, Bert Luff, Harry Green, Billy Saunders, John Weeks, Willy Saunders, Clark, Bill Moorey, Vic Etherington, Len Moorey. Front row: Arch Sutton, Freddie Boyes, Reg Sutton, Bert Knowles, Bill Winch, Frank Denyer, Roe, Joe Ryman, John Carr, Arthur Cherry, Harry Young, George White, Noah Moorey, Obie Denyer and Tom Herbert.

BEN CHANDLER AND GINGER delivered the groceries from John Irish's shop at 93 Wey Hill. Ginger was kept in the stables behind the shop. In the background beyond the yard gates is the St Christophers Road side of the building that became Haslemere Library in November 1947.

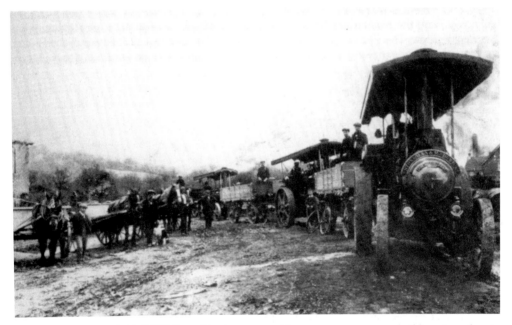

STONEMAN AND MADGWICK used both steam and horsepower to extract building stone from a quarry at Hammer. The rapid expansion of Halsemere and Hindhead in the 1890s and early 1900s created a great demand for building materials of all kinds. These were supplied by Stoneman and Madgwick with bricks coming from John Grover's Hammer Brickworks, the chimney of which is just visible behind the leading traction engine.

A MOVEMENT TO REVIVE peasant arts and crafts in Britain began towards the end of the nineteenth century largely inspired by Godfrey Blount. Local craft workshops were established including the Weaving House built in Kings Road in 1898. There the Haslemere Weaving Industry began under the auspices of Joseph King. Both his wife Maud and Ethel Blount were involved in weaving cloth here, while nearby other weavers worked at Green Bushes. Silk was woven at the St Edmundsbury Works established in 1901 by Edmund Hunter and at the Spitalfields Works (see p. 153). Other crafts included the Hammer Vale Pottery and Faience Works of Mr W. W. Stalworthy, who produced some delightful little model pigs, and the Haslemere Wood Working Industry where furniture was handmade at Foundry Meadow. The Peasant Arts enterprise was disbanded in 1927 although the Blounts continued for a while making toys at St George's Hall. Harry Hedges continued to weave silk and the Weaving House stayed open into the 1930s.

"THE THREE SHUTTLES"

ESTABLISHED 1897

THIS OLD WEAVER'S SIGN (over 200 years old) has hung for many years outside

THE

WEAVING

HOUSE,

113, King's Rd.

Haslemere,

Surrey.

JOSEPH KING (right) was a barrister who originated from Liverpool. He was a leading figure in the Peasant Arts revival and set up the Weaving House in Kings Road. From 1910 to 1918 he was Liberal MP for the North Somerset constituency. He lived at Hill Farm, Camelsdale during the 1920s and it was here that George Bernard Shaw addressed, with some sarcasm, a local gathering after the recent elevation to the peerage of Arthur Ponsonby. Joseph King later moved to Tilford but retained his local interest as curator of the Peasant Arts Society collection which is now housed in Haslemere Museum.

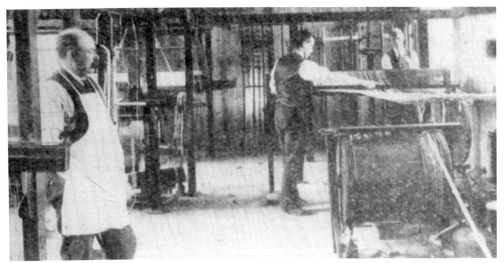

SPITALFIELDS SILK WEAVING WORKS was the business of Harry Hedges (left) and operated during the early 1900s from a small wooden building by the stream at the bottom of Wey Hill. The works produced silk damasks of the highest class, brocades and also velvets both for dressmaking, and domestic and church furnishings. Silk was also woven at St Edmundsbury by Edmund Hunter and some of his fabrics were used at Buckingham Palace. In August 1905 Queen Alexandra visited an exhibition at Haslemere School where she made several purchases and placed orders for other items to be made by the local weavers. The Spitalfields Works was later used as the Kingdom Hall of Jehovah's Witnesses. A new Kingdom Hall has recently been constructed over and around the original wooden building.

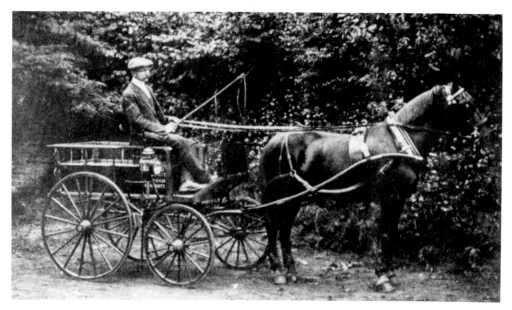

GEORGE PESKETT was a poultry dealer who lived at Yew Tree Cottage, Whitmoor Vale, from where he supplied local people, hotels and tradesmen around Grayshott just before the First World War. Before this he worked for the butcher Mitchell in Headley Road (see p. 75). He was one local victim of the influenza epidemic in 1919 that filled the military cemeteries at Bramshott and Grayshott more effectively than the German Kaiser.

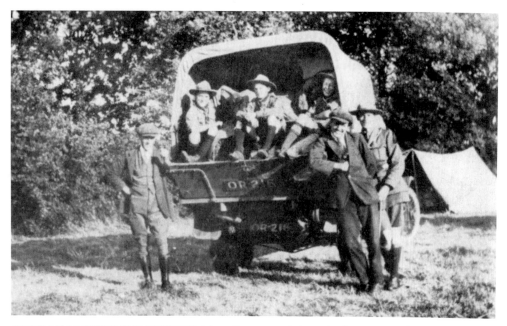

CHAPMAN, LOWRY AND PUTTICK drivers Bert Jones (left) and Bill Hicks collecting the Grayshott boy scouts from their summer camp.

SECTION FOURTEEN

Grayswood

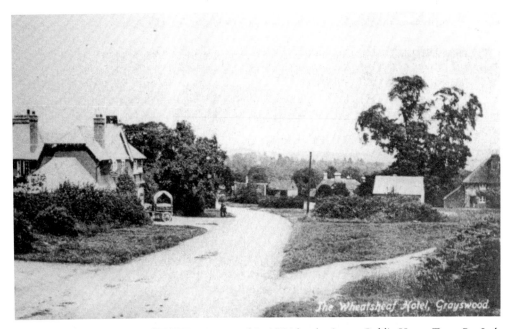

THE NEW WHEATSHEAF HOTEL was opened in 1904 by the Surrey Public House Trust Co. Ltd.
Before this the old Wheatsheaf Inn had been across the road for at least 150 years at what is now a
private house called Hawks Stoop. It was here that Lord Tennyson is reputed to have sometimes joined
the locals for a glass of ale – having walked down from his home on Blackdown.

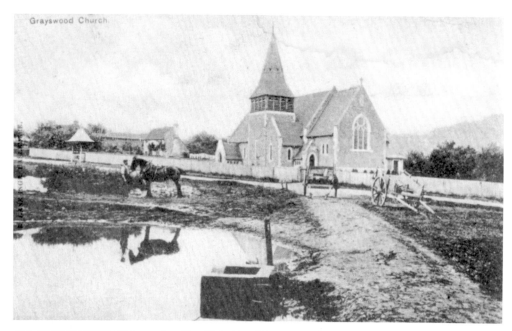

ALL SAINTS' CHURCH was the gift of Mr Alfred Harman who lived at Grayswood Place and gave £4,500 towards the total building cost of £4,750. The church was designed by Axel Hägg (pronounced Haig and spelt in the local directories Haigh), a Swedish naval officer who came to Britain in 1856 and became interested in church architecture. He joined the office of Mr Ewan Christian, architect to the Ecclesiastical Commissioners, devoted the rest of his life to designing churches and settled in Grayswood in 1892. The church was consecrated by the Bishop of Winchester in February 1902. Unfortunately Mr Harman's wife was the first person to be interred in the new churchyard. Axel Hägg died in 1921 and his grave is marked by a large tombstone engraved with a ship in full sail.

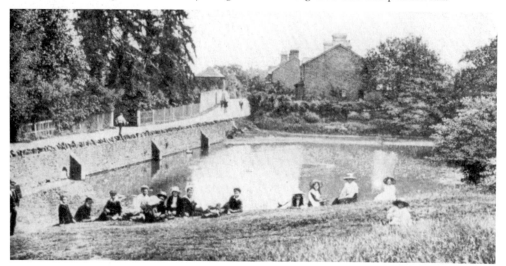

THE POND alongside Lower Road and almost opposite Grayswood School was a favourite haunt of children both before and after lessons. The original pond was filled in some time during the 1930s but has now been restored a little further away from the road.

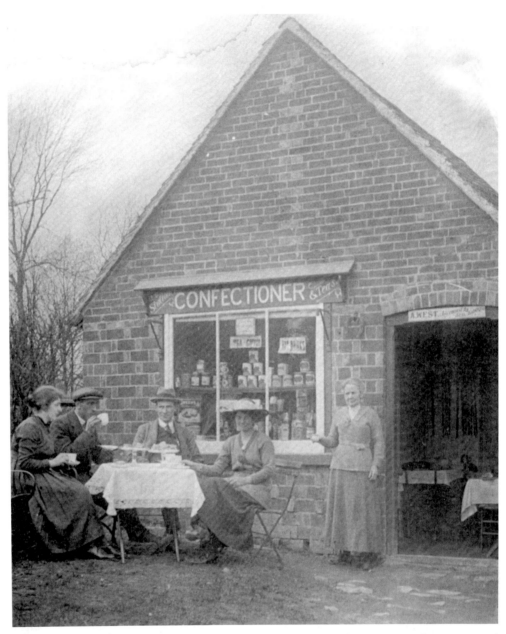

THIS LITTLE CAFÉ with a group of four Edwardian cyclists sitting down to enjoy afternoon tea and cakes was just below the Wheatsheaf and on the same side of the road. Besides teas for visitors, the shop, run by A. West, also sold stationery, cakes, sweets, tobacco and mineral waters. There is a Codd (marble-stoppered) bottle of lemonade in the window to the left of the lady wearing a hat. Later, this building was Mrs Smithers' shop until she moved into larger premises next door. It was also used by Ernest Wright during the 1920s as a cycle repair shop. In more recent times the building was converted into a lock-up garage. When the village shop closed in the 1980s it was made into two flats, a change that necessitated the demolition of the old café.

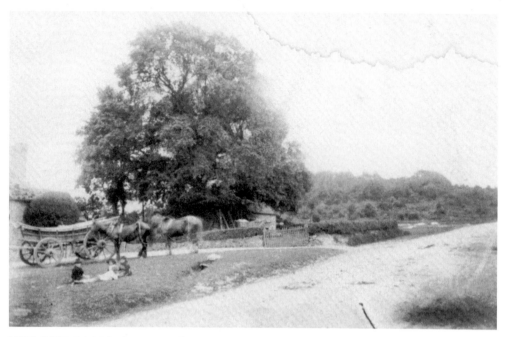

THIS VIEW LOOKING SOUTH from outside the old Wheatsheaf Inn on 18 August 1877 was photographed by John Wornham Penfold. Barnard Motors, formerly Russell Relf, is now to the right of the large tree; the cottage beyond is still there but is now partly hidden by the modern garage buildings.

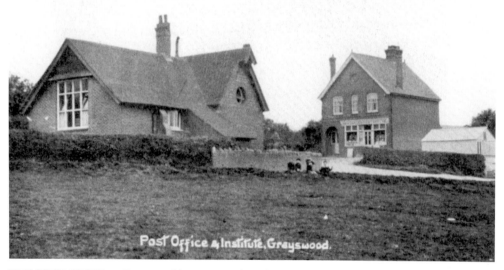

Post Office & Institute, Grayswood.

THE POST OFFICE at Grayswood became another of the long list of local village shops to disappear when it closed more than twenty years ago. However, in 1910 it was a new building opposite the Grayswood Club and Institute which has been enlarged a little and still stands on the corner opposite the church and overlooking the green. The Institute was built originally as the village school, but this was soon too small and was replaced by the present, larger school, built just across the green and opened in January 1905.

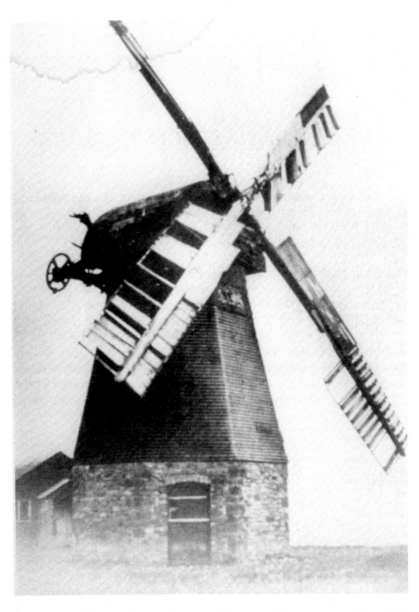

HASLEMERE WINDMILL actually stood on the ridge above Grayswood, to where Higher Combe now stands, until it was pulled down in 1886. The mill was in working order until the mid-1870s but then fell into disrepair as its owner William Oliver relied more on the steady water power available at Shottermill. Following the demolition of the windmill on a bank holiday he treated all his helpers to a barrel of beer. Parts of the machinery were removed to the water-mill at Cooksbridge, Fernhurst, and to Mr Oliver's mill at Shottermill. However, as we have seen over the preceding pages, the wind that had turned the mill sails was not the only one blowing through the area. Many changes happened during the next century and some of these have been recorded in this collection of old photographs. We hope the winds of change in the future are as well recorded as they have been by photographers since Haslemere windmill ceased grinding corn around 150 years ago.

ACKNOWLEDGEMENTS

This book was made possible by the co-operation of a number of friends and relatives who have willingly put their treasured photographs at our disposal. We should like to thank the following people for permission to use their pictures and for help in the preparation of this book:

Carla Barnes • Judy Bright • Jonathan Foster • Colin Futcher • Lawrence Giles
Toby Harmer • Maurice Hewins • Miss Lucy Hollist • Peter Holmes • Steve Homewood
Clive Humphries • Eddie Keemer • Miss Violet Kevan • Richard Killinger • R. and G. Madgwick
Donald Mann • Snowy Mansbridge • Miss Minnie Mills • Bill Oakford • Richard Peskett
Vi and Cyril Queen • Peter Read • Chris Shepheard • Gwen Styles • Roger Vaughan
Tony Waddell • Andy White • Ruby Winter • Dennis Young • The Automobile Association
The Haslemere Educational Museum • The *Haslemere Herald*
The Local Studies Library for Surrey in Guildford • The *Surrey Advertiser*.